PAINTING IN ALKYD

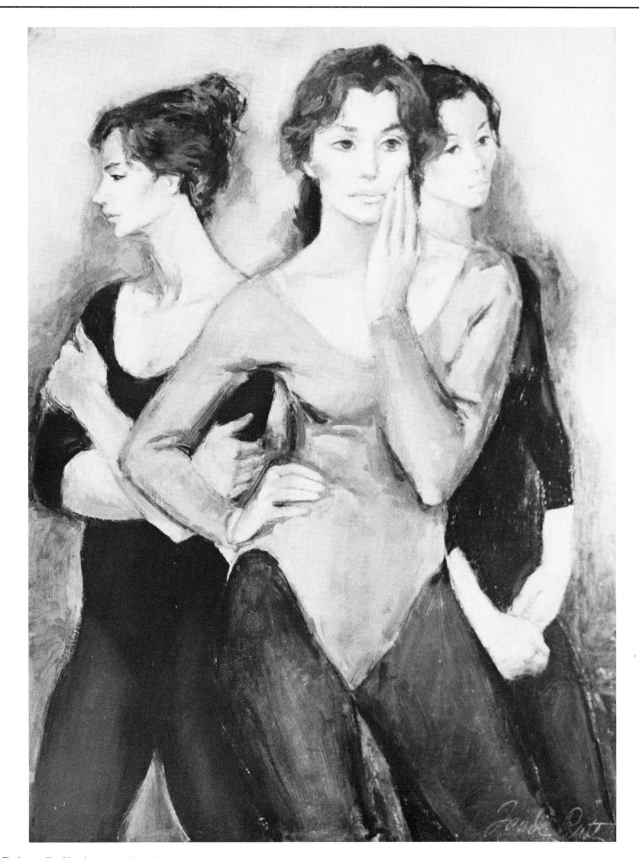

Prima Ballerina by Jan De Ruth, alkyd on canvas, 38″ × 28″ (97 × 71 cm), collection Mr. and Mrs. Sam Sidewater, courtesy Gallery 306. This figure study displays the diversity of alkyd brushwork. The skin is smoothly blended so that the strokes all but disappear, while slender, precise strokes capture the detail of the hair. The dancers' costumes are rendered with broad strokes—most obvious in the central figure. And the background shadows are painted with short, scrubby strokes to suggest the texture of the wall behind the dancers.

PAINTING IN ALKYD

BY WENDON BLAKE / Paintings by Ferdinand Petrie

WATSON-GUPTILL PUBLICATIONS/NEW YORK
in cooperation with WINSOR & NEWTON

Para Julio, con un fuerte abrazo

Copyright © 1982 by Watson-Guptill Publications

First published 1982 in New York by Watson-Guptill Publications,
a division of Billboard Publications, Inc.,
1515 Broadway, New York, N.Y. 10036

Library of Congress Cataloging in Publication Data

Blake, Wendon.
 Painting in alkyd.

 Includes index.
 1. Polymer painting. I. Petrie, Ferdinand,
1925– II. Title.
ND1535.B58 751.4'9 82-1953
ISBN 0-8230-3553-0 AACR2

Manufactured in U.S.A.

First Printing, 1982

2 3 4 5 6 7 8 9/86 85 84 83 82

Acknowledgments

The starting point of this book was an article that carried the same title, "Painting in Alkyd," published in *American Artist* in October 1980. My thanks to Glenn Heffernan, publisher of *American Artist*, and M. Stephen Doherty, Editor, for commissioning the article and for granting me permission to use many of the words and pictures from it in this book.

The book would have been impossible, of course, without the aid of my many friends at Winsor & Newton—on both sides of the Atlantic—the great old art materials manufacturer that takes the credit for introducing the first alkyd colors and mediums for artists. In the United States, I owe special thanks to Brian J. Heath, President of Winsor & Newton and a valued friend for twenty years; to Steve C. Pleune, Vice-President, whose enthusiastic help made my job not only easier but a lot more fun; and Missy Small, who was always ready to pitch in with efficiency and a big smile.

In Great Britain, I'm grateful to Peter C. Knee, former Managing Director of Winsor & Newton, who threw all doors open to me when I first began to investigate alkyd; to Alan C. Brown, my charming and informative host on my visits to the headquarters in Wealdstone; and to Fred Beckett, the newly appointed Managing Director, who represents a miraculous combination, a dynamic executive who's also an accomplished painter. And I owe a very special debt to Peter J. Staples, Technical Director at Wealdstone, who has been my mentor during the research phase of this book, my critic during the writing phase, and my indispensable source of facts at all times.

Every writer has a silent partner who works tirelessly (and usually without credit) to make the book a success: his publisher. So I want to express particular gratitude to my editor, Connie Buckley, who combed my quirky writing with such tact and sensitivity; to Hector Campbell, who handled the production of the book with exquisite care and fought the usual struggles with separators and printers, always with amazing good humor; and to Bob Fillie, who designed the book with his special combination of clarity and style. And one other silent partner who deserves a bow is Scope Associates, the superb laboratory that processed and printed all the black-and-white photos in this book with exceptional craftsmanship, as always.

Of course, the most important partner of all is Ferdinand Petrie, who painted all the step-by-step demonstrations—as well as the many technical illustrations in black-and-white—with his usual versatility and mastery of the medium. There would be no book without him.

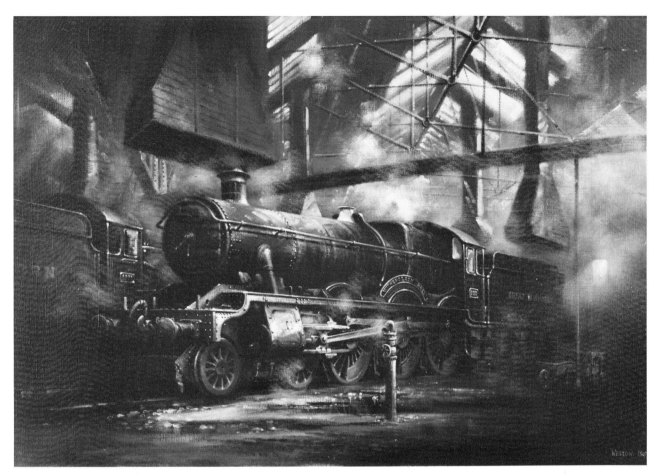

Great Western Giant by David Weston, alkyd on canvas, 20″ × 30″ (51 × 76 cm), collection Witherslack Hall Locomotive Society. The rich pattern of light and shadow is produced by a variety of techniques. The soft, mysterious gradations—like the smoky passage at the extreme right and the misty light in the upper left—are created by softly blending creamy alkyd color diluted with painting medium. The stronger lights—like the shiny areas on the engine and the patches of light coming through the roof—are scumbled and drybrushed with thicker color. Notice how the light-struck details of the engine are drybrushed, light over dark, with a slim brush. In all these drybrushed and scumbled, light-over-dark areas, the texture of the canvas breaks up and vitalizes the strokes. Because alkyd dries to the touch so swiftly, it's easy to work from dark to light, first blocking in your darks and then letting the surface become tacky or "touch dry," and finally brushing translucent lights over the darks.

Contents

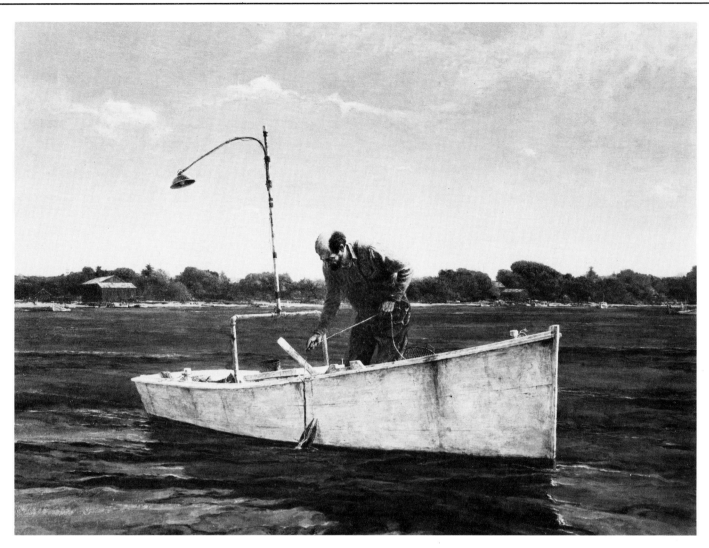

Off Harker's (detail) by R. B. Dance, alkyd on gesso panel, private collection. Working with liquid, highly diluted color, the artist has developed a fascinating interplay of precise detail and subtle gradations of tone. The luminous sky is softly blended from dark to light—dark at the zenith and glowing light at the horizon. The boat and the figure are executed with small strokes of fluid color—as are the details on the distant shore—to create sharp-focus detail. The water is broadly painted, but crisp, slender strokes pick out the lights and shadows of the waves and ripples. A few touches of detail go a long way: the artist doesn't overdo those precise strokes, but lets them *suggest* more detail than is really there.

Introducing Alkyd. Since the early 1970s, paint chemists have been predicting that the next major development in artists' colors would be alkyd. In his widely read column in *American Artist* magazine, famed color chemist Ralph Mayer said again and again that artists would "hear from the alkyds someday." Now, at last, alkyd colors have arrived in the art supply stores, and artists are asking: what is alkyd, how does it behave, and how do you work with it? This book will attempt to answer these questions.

About Binders. Whether you work in oil, watercolor, acrylic, egg tempera—or alkyd—most of your colors are made of the same pigments. It's the binder that changes. The binder is the liquid "glue" that's blended with powdered pigment to manufacture the thick, colored paste that you squeeze out of the tube. And it's the binder that makes the pigment stick to the painting surface. Each type of paint is actually *named* for its binder, since the binder determines how the paint behaves. Thus, oil paint is named for the vegetable oil that gives the paint its buttery consistency and slow drying time. In the same way, acrylic is named for the fast-drying, water-soluble plastic that generally gives the paint a consistency like that of thin cream. And alkyd colors are named after a new kind of binder called alkyd resin.

Alkyd Resin. Throughout history, artists have searched for the ideal binder. Soon after the development of oil paint in the fifteenth century, artists discovered that various natural resins—sticky, honeylike fluids derived from plants—could be added to the vegetable oil to speed drying time, make colors more luminous, and toughen the dried paint film. (This is why so many contemporary oil painters prefer to dilute their colors with a medium that contains a resin such as damar, mastic, or copal.) The development of alkyd is the latest step in the long quest for the perfect binder. Like the oils and resins used in oil painting for the last five centuries, alkyd is of plant origin. Working with natural materials derived from plants and other organic matter, the manufacturer extracts a series of chemical "building blocks" to construct a kind of "ideal" resin that's highly adhesive; pale and transparent; soluble, when wet, in turpentine or petroleum solvent; tough, flexible, and resistant to solvents when dry. Particularly important, alkyd resin dries more rapidly than the linseed oil that's used as the binder for most oil paints, but more slowly than the plastic resin that serves as the binder for acrylic.

Why the Name? Why the name *alkyd*? The chemical building blocks are mainly alcohols and acids. Hence *al-cid*. The spelling was changed to *alkyd* because it's easier to pronounce.

Alkyd Colors and Mediums. In the manufacture of alkyd colors, familiar pigments (such as those used in oil, acrylic, and watercolor) are blended with liquid alkyd resin and just enough petroleum solvent to produce a smooth paste. There are three alkyd painting mediums, all of which are essentially alkyd resin, made in three different consistencies: liquid, a lightweight gel, and a heavier gel. Alkyd tube colors and mediums can be diluted with turpentine or any of the petroleum solvents labeled mineral spirits, white spirit, petroleum distillate, rectified petroleum, etc. You'll learn more about colors, mediums, and solvents on pages 12 and 13.

How Alkyd Looks. Although the appearance of a finished painting naturally reflects the artist's individual way of handling paint, there *is* a unique character to the surface of an alkyd painting. It's the resinous binder that creates the special look of alkyd color. Pure tube color, softened with a touch of solvent, brushes out to a smooth, extraordinarily luminous paint film that bears a striking resemblance to the highly resinous paint of seventeenth-century Flemish masters such as Rubens and Van Dyck. At first glance, the colors may seem brighter than those of other media. But this brightness has nothing to do with the pigments—which are the usual colors you're accustomed to working with—but is actually the effect of the alkyd resin. It's as if the paint contained its own varnish. The diluted tube color also dries to a satin sheen that's consistent throughout the painting surface—not dull in some spots and shiny in others, like too many oil paintings. And the brush stroke is clearly defined, whether you're working in broad strokes or exact lines. In fact, alkyd rivals acrylic and tempera in its ability to render sharp detail.

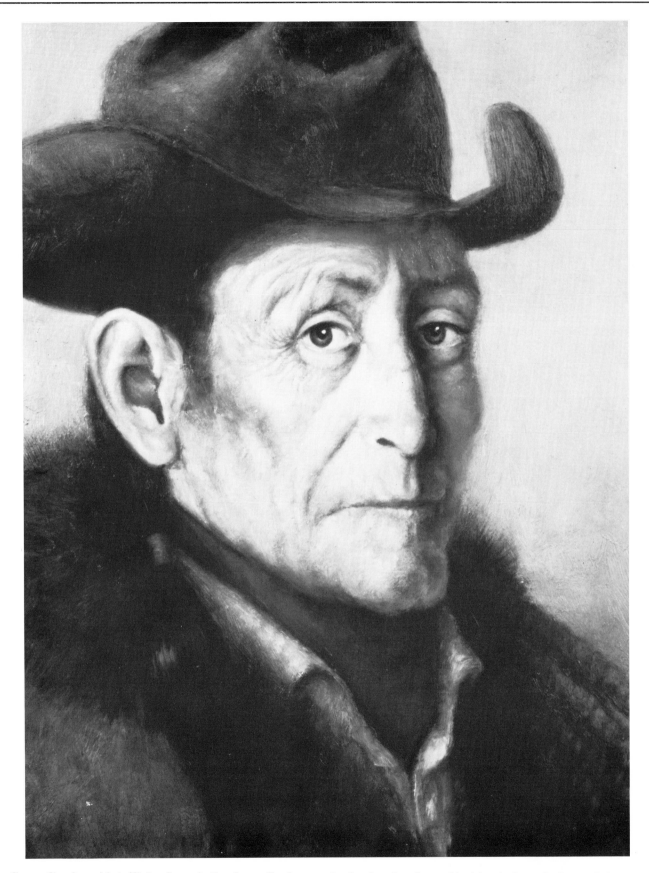

Crow Cowboy (detail) by Joseph Dawley, alkyd on panel, collection Winsor & Newton. The drying time of alkyd lends itself to the rapid execution of subtle blending and sharp-focus detail in a surprisingly short time. Here, the artist uses highly diluted alkyd color for the softly blended gradations of the lights and shadows on the face—as well as on the hat and other clothing—and then goes back to render the fine details of the skin and features as soon as the surface is tacky.

Drying Time of Tube Color. When artists describe alkyd to someone who hasn't tried it, the first thing they usually mention is drying time. And there's no question that drying time is one of the distinctive features of this new medium. A layer of alkyd paint stays moist and pliable long enough for the artist to execute those soft, blended passages that can't be done in a fast-drying, aqueous medium like acrylic. But alkyd becomes tacky or "touch dry" soon enough to overpaint on the same day—if you do it gently—which you can't do with oil. The next day, your picture is dry enough to overpaint without disturbing the first day's work.

Working Time. Let's look at this timetable more closely and analyze what might be called "working time." As long as you keep working on a section of a picture—which means brushing on fresh color, medium, and solvent—the paint stays wet. But as soon as you walk away and stop working, the solvent starts to evaporate and the drying process begins. Within three or four hours, a paint layer of normal thickness will be tacky and resistant to smudging. After eight to twelve hours, the painting will be dry to the touch; you can soften the surface only with solvent, and you can paint over it with a gentle touch. At the end of eighteen to twenty-four hours, the paint looks and feels dry enough to overpaint easily, although it will still yield to solvent. But after forty-eight hours, the paint can't be budged by any of the usual solvents—such as turpentine or petroleum thinner—and the picture is *really* dry. Thus, the whole drying cycle takes about forty-eight hours. Of course, the process is faster if you paint thinly (or live in the tropics) and slower if you paint very thickly. There's also a difference in the drying time of the two grades of alkyd; more about this on page 13. But the essential point is that you've got about a day's working time—and a picture that's dry enough to overpaint the next day.

Uniform Drying Time. When you work with alkyd, you'll also notice that all the tube colors dry at the same rate. This is a radical departure from oil painting, in which some colors, such as burnt umber, dry overnight, while colors like the cadmiums can stay wet for a week.

Advantages of Alkyd's Drying Time. The unusual drying cycle of alkyd isn't just a convenience for impatient painters—it's really the key to the versatility of this new medium. Obviously, alkyd is ideal if you're an *alla prima* painter, a direct painter who works quickly and decisively, aiming for a finished picture by the end of a half-day or full-day painting session. When you paint outdoors, for instance, it's a blessing to go home with a canvas that's dry to the touch. And for illustrators—or art students—with a one-day assignment to deliver, that overnight drying time is a lifesaver. On the other hand, if you're a slow, methodical painter, alkyd is perfect for working in a series of stages, gradually building a picture, layer upon layer. Because an alkyd paint layer is tacky within hours, you can begin overpainting—if you don't scrub too hard—as soon as the underlying color solidifies. Most surprising of all, you can paint precise detail in strokes of fluid color *right over the tacky paint*—something that won't work in any other medium. And if you're fascinated by the old-master techniques of underpainting and glazing, you can underpaint one day and then begin glazing the following morning, when the surface is absolutely dry. (If you've tried this in oil, you know that it can take several *days* for the underpainting to dry.)

Permanence. Alkyd resin dries to a clear, transparent, virtually colorless film that minimizes yellowing, resists darkening, and preserves the clarity of the pigment. (Remember the bright, clear colors of the Flemish masters, whose highly resinous paint films have lasted so well over the centuries.) The alkyd paint film is harder than oil paint, yet surprisingly resilient, and so an alkyd painting will resist cracking, wrinkling, atmospheric pollution, and the sheer physical strain of handling and moving the picture. And because a dried layer of alkyd color is insoluble in turpentine and the standard petroleum solvents used in the studio, an alkyd painting is easy to clean without marring the paint film. Like acrylic, alkyd first proved itself as a top-quality house paint. Ralph Mayer points out that "alkyd resins have for many years enjoyed a very high reputation as . . . house paint vehicles, which outlast and otherwise outperform all . . . other materials." Since a wall usually takes more punishment than a picture, this seems to be impressive proof of the durability of alkyd colors for artists.

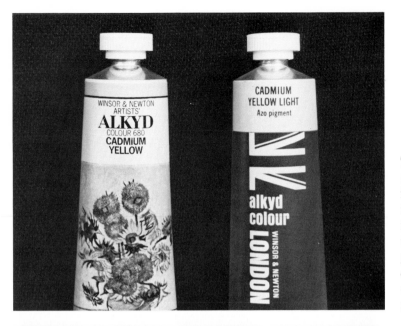

Tube Colors. The two grades of alkyd tube colors are permanent, although they differ in price. Both contain the same alkyd resin, but the economy London Alkyd (right) is made with less expensive pigments than the Artists' Alkyd (left). The economy grade also has a softer consistency and dries somewhat more slowly because it contains a small amount of linseed oil. The artists' grade has greater tinting strength.

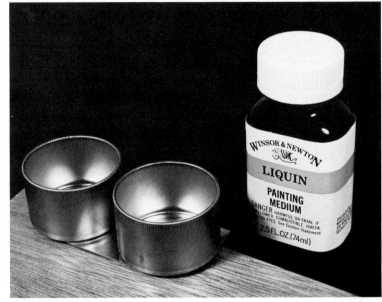

Liquid Medium. The standard liquid medium for alkyd colors is Liquin, a blend of alkyd resin and rectified petroleum. Fill one of your palette cups (or dippers) with this medium and fill the other with solvent—rectified petroleum, turpentine, mineral spirits, white spirit, etc. You can dilute your tube colors with solvent or medium *or* a combination of medium and solvent. Liquin was originally developed for oil painting long before alkyd colors were available for the artist. It's equally compatible with oil and alkyd tube colors.

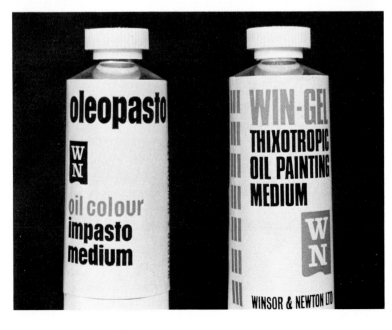

Gel Mediums. Alkyd painting mediums are also manufactured in gel form. Win-Gel, the lightweight gel medium (right), brushes out smoothly like the liquid medium shown above but is also suitable for bold brushwork. Oleopasto, the heavyweight gel medium (left), is specially formulated for impasto painting with brush or painting knife. As the labels on the tubes indicate, both gel formulas originally won popularity as oil painting mediums.

Tube Colors. Scanning the alkyd color charts, you'll see the familiar pigments that have been used in oil painting for the past century or more: the umbers, siennas, and other earth colors; the cadmiums; and classic blues such as ultramarine, cobalt, and cerulean. You'll also find the newer products of the twentieth-century chemical laboratory—such as phthalo blue and green, and the azo reds, oranges, and yellows—all time-tested veterans by now.

Two Grades of Alkyd Colors. Like many brands of oil colors, alkyd colors are manufactured in two grades: the more expensive Winsor & Newton Artists' Alkyd and the economy-priced Winsor & Newton London Alkyd for the artist or student on a tighter budget. The Artists' Alkyd has greater tinting strength. The London grade dries somewhat more slowly and the consistency is a bit softer because the paint contains a speck of linseed oil. But both grades are permanent. Both contain the same alkyd resin and both are made of permanent pigments. Why the price difference, then? To place the less costly tube colors within reach of the artist on a budget, the manufacturer replaces certain expensive pigments with less expensive ones. For example, the cobalt blue in the higher-priced tube is made from cobalt aluminate, while the lower-priced tube contains a mixture of two less costly pigments. However, both tube colors are permanent and suitable for professional work.

Color Selection. Over thirty alkyd tube colors are now available—far more than most painters need on their palettes. The painting demonstrations in this book are all done with ten basic colors—all-purpose hues that most artists keep on their palettes—plus a few optional tubes for special purposes. If you're trying alkyd for the first time, ten colors will be enough to get started: two blues, two reds, two yellows, two browns, black, and white.

Basic Palette. Here are the basic ten, plus a few others to try. The recommended colors are in pairs. One member of each pair is bright; the other is more muted. Ultramarine blue (also called French ultramarine) is dark, subdued, and a bit warm, while phthalo blue (short for phthalocyanine blue) is cool and brilliant. The fiery cadmium red pairs off well with the cooler, darker alizarin crimson. Cadmium yellow is brilliant and sunny, while yellow ochre is tannish and retiring. Burnt umber is a dark, somber brown that balances nicely against burnt sienna, a coppery brown with a hint of orange. The classic black is ivory black. Buy the biggest available tube of titanium or flake white. Flake white looks a bit warmer to the experienced eye, but either one of them will do the job.

Optional Colors. You can mix lots of greens by combining blues and yellows, and so you don't really need a green on your palette—but you might like to keep viridian on hand. You might also try two cool, delicate blues: cobalt and cerulean. Stick to a limited palette while you're learning what alkyd can do. Then you can begin to explore the full range of colors on the manufacturer's chart.

Alkyd Mediums. Like oil and acrylic, alkyd is a thick paste as it comes from the tube. You can easily paint with tube color and solvent—as you can with oil color—but you can produce a livelier consistency by adding one of the three alkyd mediums. The standard liquid painting medium, called Liquin, is a blend of alkyd resin and a fair amount of solvent—producing creamy color for smooth brushwork and fine detail. A lightweight gel medium, called Win-Gel, creates a soft, pasty consistency that's equally good for rougher brushwork and subtle blending. And there's a thicker gel medium, called Oleopasto, for impasto painting with brush or knife. All three mediums are essentially alkyd resin, made in different consistencies. When you add them to your tube color, you actually add more resin, thus heightening the gloss of the final picture.

Solvents. Alkyd tube color and all three mediums can be diluted with the same solvents used for oil painting: turpentine and mild petroleum solvents such as mineral spirits, white spirit, and rectified petroleum. These will all remove color from the painting surface on the first day or two, when the painting is tacky or dry to the touch. But they won't budge the dried color after forty-eight hours. It's there to stay!

Smooth Color: These apples (right) are painted with tube color that's been diluted with Liquin to a smooth consistency similar to that of thick cream. This paint consistency is ideal for subtle blending and rich tonal gradations.

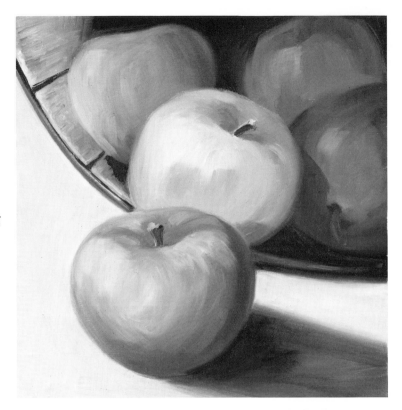

Smooth Color (detail). Here's an enlarged close-up of a section of the painting shown above. The liquid medium produces smooth, flowing color. The brush glides easily over the curves of the apple, modeling the form with fluent strokes of light, halftone, and shadow, and delicate highlights. The artist blends the strokes gently together, allowing them to remain visible on the apple, but fusing and obliterating the wet strokes in the shadow at the right, which now becomes a solid, unbroken tone.

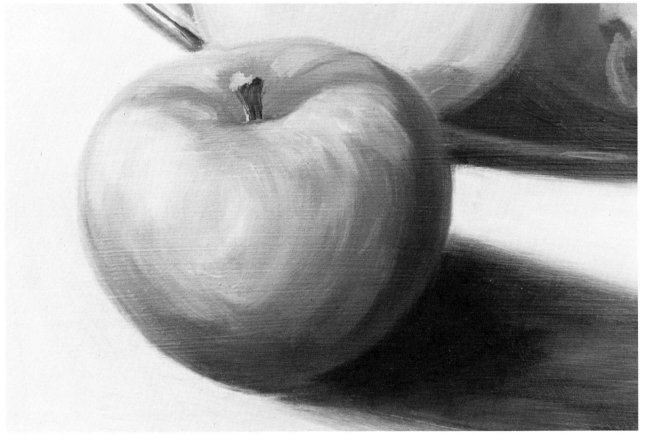

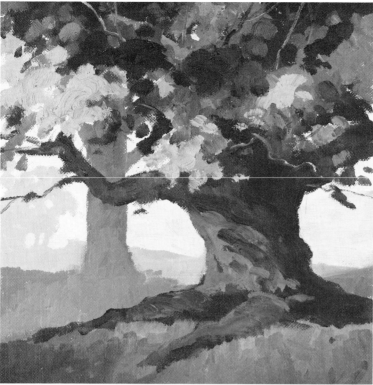

Thick Color. Blended on the palette with gel medium—Win-Gel or Oleopasto—alkyd color becomes a thick, juicy paste, stiff enough to make the brush stroke stand up from the painting surface, yet still soft enough to brush swiftly and boldly across the painting surface.

Thick Color (detail). In this enlarged close-up of the painting shown above, you can see how the thick tube color—modified with gel medium—retains the imprint of the bristles in the thick strokes that represent the lighted foliage. Yet the color still brushes out smoothly in such dark areas as the shadow on the right side of the tree trunk. The color on the palette is surprisingly soft, so that a pointed, soft-hair brush can render such details as the thin, curving twig at the lower right.

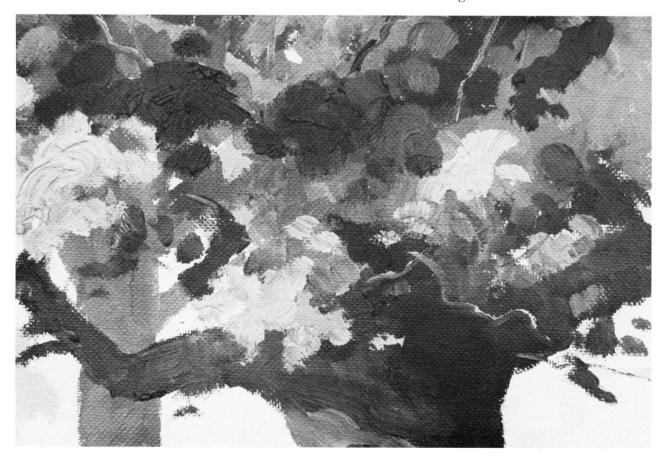

Versatility of Alkyd. Alkyd is so versatile—mainly because of the rapid, but not *too* rapid drying time—that it lends itself to a long list of painting techniques. The medium is also so new that artists are still surprising themselves with unexpected ways of working with alkyd. As you explore the many possibilities of these colors and mediums, remember that you *are* trying something new—in contrast with oil, watercolor, and pastel, which have all been around for centuries. Try to put aside preconceptions and old habits. Don't treat alkyd as if it's just a faster-drying oil color or a slower-drying, easy-to-blend acrylic. Alkyd isn't an "improvement" over some older medium. Oil and acrylic are just as good as ever. Alkyd is something *different*. Alkyd has its own unique handling qualities, which you've got to learn by experience, just as you learn to handle oil, acrylic, watercolor, or pastel. As you turn the next sixteen pages, you'll see how a variety of American and British artists have found their own personal approaches to painting in alkyd.

Learning About Alkyd. There are two basic approaches to painting a picture in any medium. You can work in a *direct technique*, which means aiming for the final effect from the very beginning. Although the job can take anywhere from a few hours to several weeks, the essential point about the various direct techniques is that each brush stroke represents the final color you expect to see on the completed picture. In contrast with the direct techniques, do try the *multiple-phase techniques* of the old masters. In these techniques, the picture is built up in separate and distinct steps, often called underpainting and overpainting. The underpainting is usually solid and opaque, while the overpainting tends to be transparent or semitransparent so that the underpainting colors shine through. The colors of the underpainting and overpainting mix in the viewer's eye to create "optical mixtures" that form the final colors of the picture.

Direct Techniques. In the gallery that follows—and throughout this book—you'll see pictures executed in a variety of direct techniques. You should try as many of these methods as possible. Experiment with free brushwork and fluid color, diluted with plenty of Liquin and solvent so that the paint handles like acrylic or gouache. Then work with more solid color, blended with Liquin or Win-Gel to a soft, buttery consistency that encourages bold, decisive brush strokes. And explore the possibilities of impasto painting, which means painting with very thick color blended with Oleopasto to form a dense paste that's equally suitable for knife techniques or for brush strokes that stand up from the painting surface. You should also try out the old masters' thick-and-thin method—painting shadows with thin, slightly transparent color and executing the lights with thick, opaque color.

Multiple-Step Techniques. As you'll see when you study the demonstrations that start on page 49, the simplest underpainting is executed in monochrome, usually gray or soft brown, followed by *glazes* and *scumbles*. These terms need some explanation. A glaze is a layer of transparent color produced by thinning tube color with painting medium until you can see right through the mixture. A scumble is a semi-transparent layer of color produced when you thin the mixture with *just* enough medium to create a kind of colorful mist. After trying the monochrome underpainting method—especially good for portraits, figures, and still lifes with complex forms and subtle lighting—experiment with various underpaintings in color. Try harmonious and contrasting colors. For example, underpaint a tree in yellow and glaze it in blue to create a luminous, transparent green. Then underpaint that tree in pink and scumble it in green to create a mysterious, warm-cool optical mixture.

Combining Alkyd and Oil Colors. Since alkyd resin and oil are chemically related, it's theoretically possible to blend alkyd and oil colors. But mixing them seems pointless because it means giving up the unique qualities of both mediums, merely ending up with oil paint that behaves more like alkyd—or vice versa. If that's what you really want, just use the alkyd mediums with your oil paints, as many artists have done for years. The most effective way to combine oil and alkyd, taking full advantage of the unique qualities of both, is to underpaint in fast-drying alkyd and then overpaint in slower-drying oil.

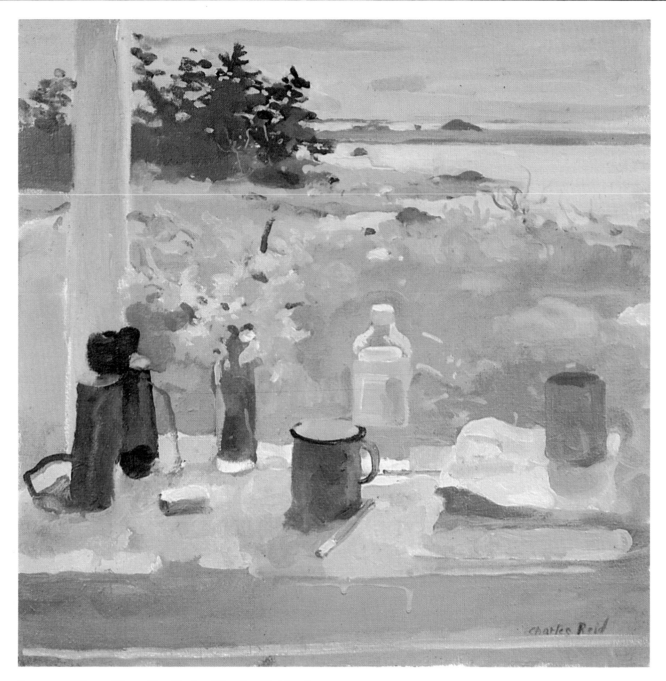

Summer View, Nova Scotia by Charles Reid, alkyd on canvas, 24″ × 24″ (61 × 61 cm), collection Winsor & Newton. The artist uses alkyd in the simplest, most direct way. He dilutes his tube color to a flowing consistency for free, spontaneous brushwork. Turpentine or petroleum solvent—alone or in combination with Liquin—will transform tube color into a smooth, creamy liquid that's ideal for loose, casual brushwork.

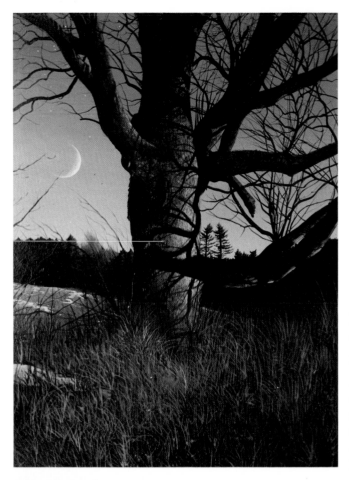

Moonrise by Daniel K. Tennant, alkyd on gesso panel, 24″ × 18″ (61 × 46 cm), collection Gary Visgaitis. Fluid color, diluted to a consistency similar to that of egg tempera, also lends itself to the tight, sharp-focus realist technique that's usually associated with tempera. The liquid alkyd holds the precise contour of the brush stroke, as you see in the branches and the dense grass in the foreground. The highly diluted color dries so rapidly that the artist can build up the grass, stroke over stroke, as he would in tempera or acrylic.

Pagham Marshes, Sussex by Norman Battershill, alkyd on panel, 7 ″ × 10″ (17 × 25 cm), collection the artist. Working rapidly with broad strokes of the bristle brush, the artist captures the fleeting light and atmosphere of the landscape before the weather changes. Fast-drying alkyd is particularly effective for outdoor painting, when the artist must work swiftly and decisively. Once again, notice how the alkyd retains the distinctive "handwriting" of the painter.

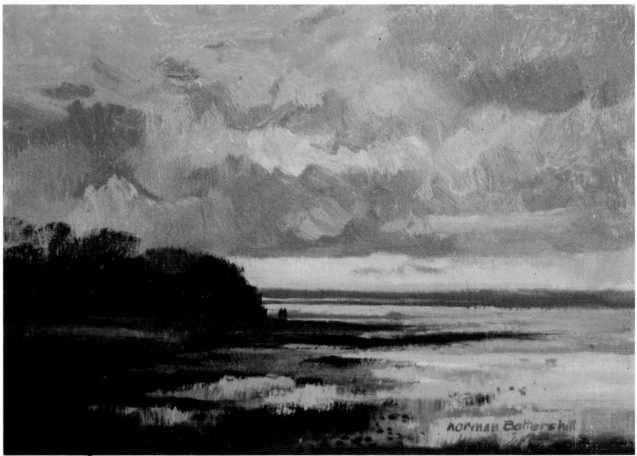

Spring Patterns by S. Allyn Schaeffer, alkyd on canvas, 16 ″ × 20″ (40 × 51 cm), collection the artist. Here the artist captures the flickering colors of leaves in light and shadow by building up a mosaic of strokes, one over the other. Because alkyd becomes tacky in a few hours, a fresh layer of brush strokes can soon be added without disturbing the underlying layer. Compare the technique of this landscape with the methods of the paintings on the facing page. The Tennant landscape is executed with precise, highly controlled strokes. The Battershill landscape is painted with broad, loose strokes. And the Schaeffer painting is developed with individual touches of color in a technique that reminds us of the Impressionists.

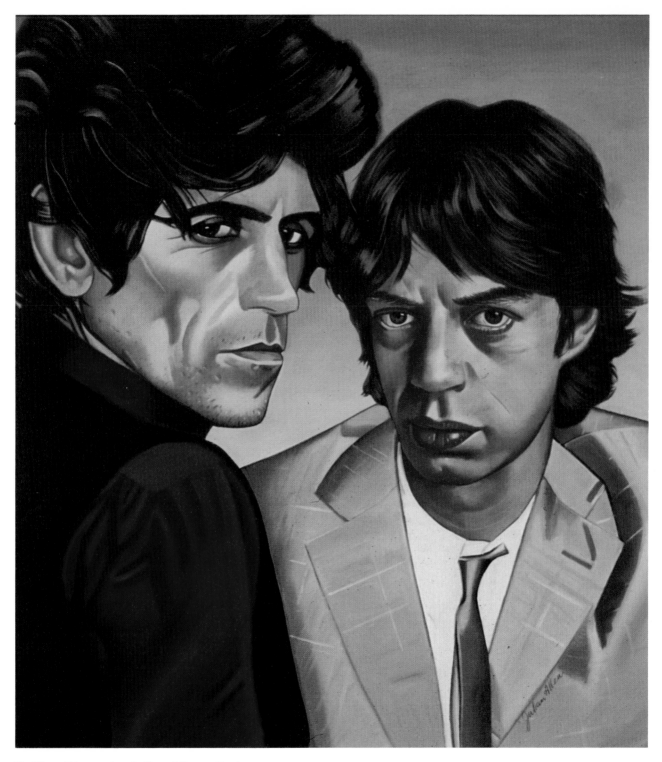

Rolling Stones by Julian Allen, alkyd on gesso-primed illustration board, 24″ × 20″ (61 × 51 cm), collection the artist. Painted for *Rolling Stone Magazine*, this double portrait is executed in smooth passages of opaque color, methodically blended with soft-hair brushes to eliminate any trace of the brush strokes. The artist actually follows a traditional oil painting technique, beginning with a charcoal sketch, then washing in areas of thin color, and gradually building up the thickness of the color until the final paint layer is solid and opaque. This particular illustration is painted on cold-pressed board (called "not pressed" in Britain) primed with a smooth coat of acrylic gesso. The artist also likes to work on gesso-primed watercolor paper.

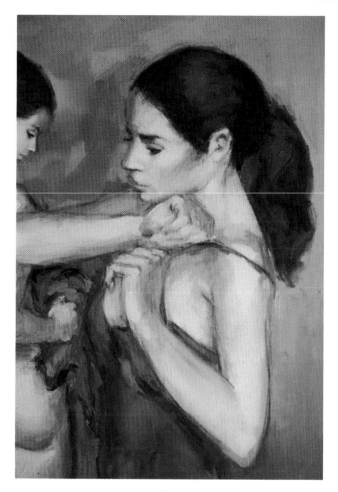

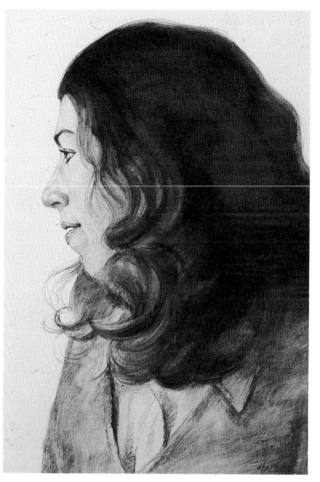

Dancers Dressing (detail) by Jan De Ruth, alkyd on canvas, collection the artist, courtesy Harbor Gallery. In contrast to the Allen double portrait on the facing page, this figure study is painted with loose, scrubby brushwork that creates a lively, constantly changing surface. The skin tones are painted in thin, warm tones that reveal a cool underpainting that shines through in the shadow areas. The costumes are painted with thicker strokes that still allow the cool underpainting to break through.

Rosie by Emanuel Haller, alkyd on canvas, 18″ × 14″ (46 × 36 cm), collection the artist. Diluting alkyd tube color with lots of solvent to a consistency similar to watercolor, the artist works with fluid, transparent washes and slender, transparent strokes. The face is modeled with delicate, almost invisible strokes, built up in diagonal clusters that follow the form. Pointed soft-hair brushes develop the detail of the hair, as well as the modeling of the face. The artist's painting medium is a 50–50 blend of turpentine and Liquin.

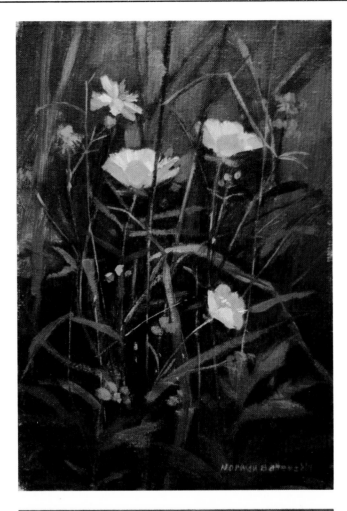

Buttercups by Norman Battershill, alkyd on panel, 7″ × 10″ (17 × 25 cm), collection the artist. The artist begins by brushing the dark background tones over the panel. These first tones are thin and fluid—quickly growing tacky enough to paint over. The artist then brushes the details of stems and leaves over the tacky undertone, completing the painting with the thick strokes that represent the blossoms. The completed painting is an interesting example of the creative control of paint consistency. The dark, thin color keeps the background in its place, while the thick strokes of the flowers move forward to command the viewer's attention.

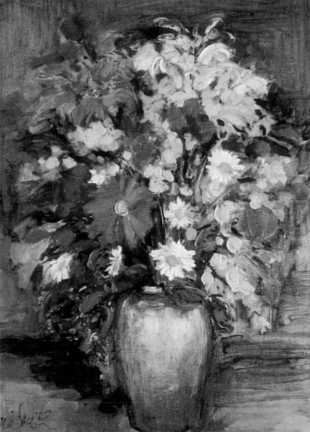

Spring Flowers by Jan De Ruth, alkyd on canvas, 24″ × 20″ (61 × 51 cm), collection the artist, courtesy Tyringham Gallery. Although the style of this flower study is radically different, the artist plans his paint consistency and brushwork in a similar way. The background, the tabletop, and the shadow on the table are all painted with thin strokes—as is the vase. But the blossoms are executed with heavy impasto. The flowers command our attention by both color and texture.

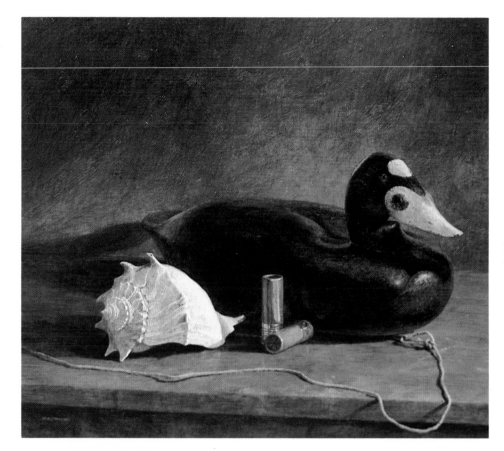

Shell, Shot, and Scoter by R. B. Dance, alkyd on gesso panel, 12″ × 16″ (30 × 41 cm), collection Mr. and Mrs. Robert Weisner. The luminous color of this still life is developed by a series of transparent glazes. The golden browns in the decoy are reflected light picked up from the table and the background. The picture radiates inner light—an effect that's typical of a painting that's dominated by transparent color.

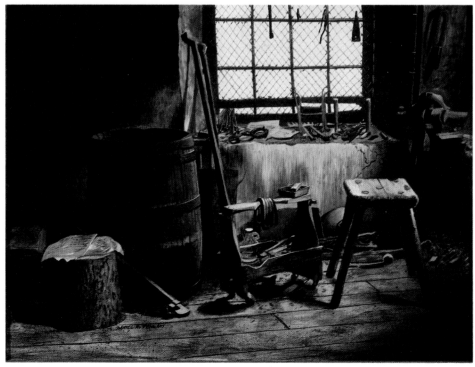

Sunday Morning by Daniel K. Tennant, alkyd on gesso panel, 18″ × 24″ (46 × 61 cm), courtesy Munson Gallery. The complex textures of this shadowy interior, with its weathered furnishings and old tools, are methodically built up with the small, highly controlled brush strokes of the "magic realist" technique, enlivened by scumbles, spatters, and drybrush passages.

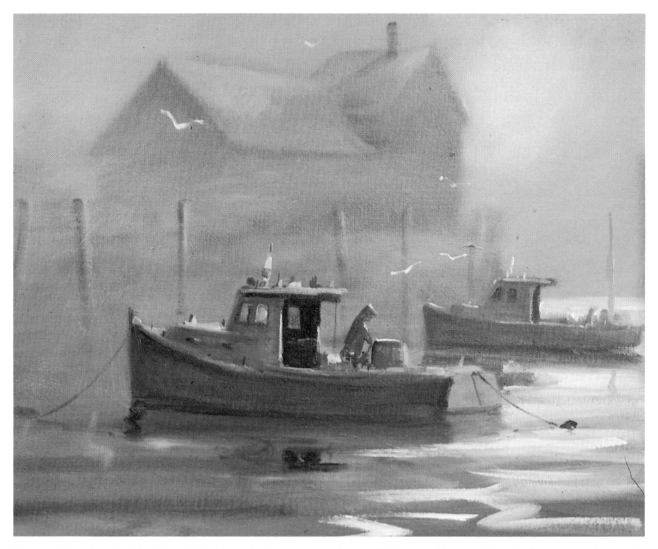

Foggy Morning by Ferdinand Petrie, alkyd on canvas panel, 16″ × 20″ (41 × 51 cm), collection Mr. and Mrs. Thomas Loych. Here's a particularly dramatic example of the technique of scumbling. The artist begins by painting the forms of the fishing shacks in the background—with colors that are distinctly darker than they appear in the completed painting. Then, when the shacks are dry to the touch, he mixes a thin, transparent "fog tone" that contains a hint of white to produce the misty, semitransparent veil that he brushes over the dark background forms. This scumble, as it's called, creates the magical atmosphere of the painting and pushes the shacks into the hazy distance. Such a scumble can be applied in a single layer, or it can be built up gradually, in a series of misty layers, until you're absolutely sure that you have the tone you want. If each scumbled layer is thin enough, it will be dry to the touch and ready for the next layer in a matter of hours. Colorful, transparent glazes can alternate with semitransparent scumbles for even more complex and subtle effects.

Motif #1, Rockport by Ferdinand Petrie, alkyd on canvas panel, 12″ × 16″ (31 × 41 cm), collection Mr. and Mrs. David Smith. This artist frequently begins with a series of thin washes of alkyd color diluted with solvent to a consistency like that of watercolor. The overall color scheme of the painting is rapidly established by this wash-in, which is tacky and ready to accept a layer of fresh color in minutes. He then completes the picture with heavier strokes of thicker color. For textural effects, he often uses drybrush strokes, as you see here.

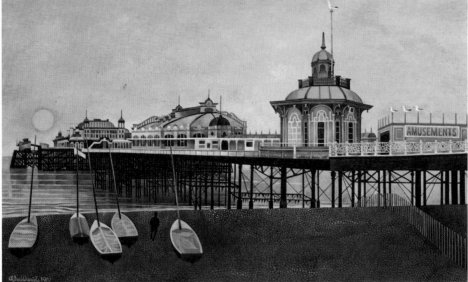

West Pier, Brighton by Alfred Daniels, alkyd on canvas, 24″ × 40″ (61 × 101 cm), private collection. The precise, elegant forms of this architectural landscape reveal a very different approach to alkyd painting. Every shape is designed with exquisite care and rendered with smooth, precise brushwork that minimizes texture and emphasizes shape and pattern. Diluted to a milky consistency and applied with soft-hair brushes, alkyd can render this kind of pictorial design as smoothly as acrylic or opaque watercolor.

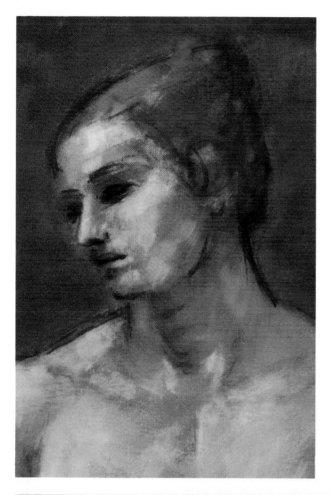

Figure Study (detail) by Janis Krisans, alkyd on canvas, collection the artist. The head, a section of a larger figure painting, is a dramatic example of the old-master technique called *grisaille*, which means painting in grays. The canvas is first brushed with a warm tone—fluid and fast-drying—and then the artist models the light and shade in varying tones of gray. Here and there, the warm undertone shines through. Normally, the grisaille simply serves as an underpainting, over which the artist brushes colorful, transparent glazes and semitransparent scumbles. But, in this case, the artist stops at the grisaille stage, which is satisfying in itself.

Fritz with a Pipe and Jug (detail) by Joseph Dawley, alkyd on gesso panel, private collection. Another head from a much larger painting, this character study is rich in detail. Working with thin color and pointed soft-hair brushes, the artist records the intricate pattern of wrinkles and stubble on this weathered face. The highly diluted color becomes tacky so quickly that he can paint the white hairs over the wrinkles in a few hours.

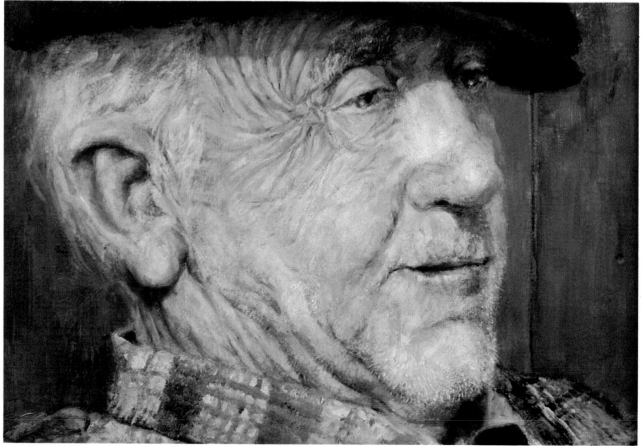

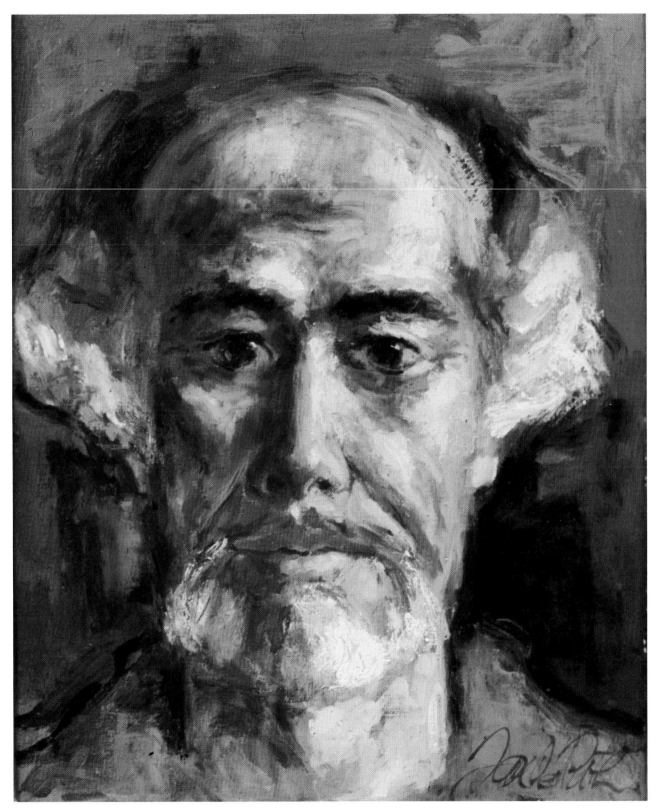

Self-Portrait by Jan De Ruth, alkyd on canvas, 16″ × 13″ (41 × 33 cm), collection Winsor & Newton. This vibrant portrait of the artist shows every trace of the painter's brushwork. Individual touches of color are placed side by side, scrubbed *over* one another and *into* one another to create flickering contrasts of warm and cool tones. The magic of this portrait is a result of the underpainting and over-painting techniques. De Ruth likes to underpaint a portrait or a figure in rich hues that shine through a loosely brushed overpainting of transparent glazes and semitransparent scumbles.

Emerald Waters by Jason Schoener, alkyd on canvas, 24″ × 36″ (61 × 92 cm), courtesy Midtown Galleries. Glazes of alkyd tube color, diluted to transparency, are the key to the glowing color of this striking landscape. The dominant golden tone is glazed over a variety of underpainting colors—warm, cool, light, dark—to create the fascinating optical mixtures that you see here.

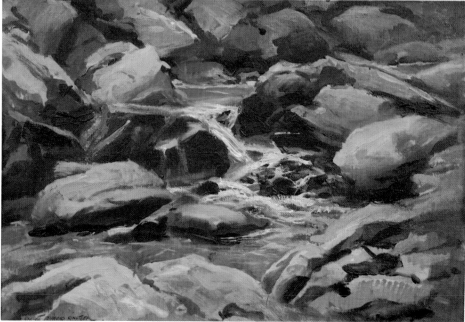

Brook by Everett Raymond Kinstler, alkyd on canvas, 20″ × 28″ (51 × 71 cm), collection Winsor & Newton. In contrast to the underpainting and overpainting method of the Schoener landscape, Kinstler works with strokes of solid color in the direct or *alla prima* technique. He alternates smooth, flowing strokes with rough, impasto brushwork to render the varied textures of rocks, water, and foam in this study of a mountain stream.

Vermont Farm (detail) by Ferdinand Petrie, alkyd on gesso panel, collection Margaret Donohue. The artist combines passages of opaque and transparent color in this section of a winter landscape. The snow is painted with solid, opaque strokes, while the tones of the distant hillside and the shadowy trees are glazes that retain the texture of the brush strokes, which suggest the detail of the foliage.

Victorian Lifeboat by David Weston, alkyd on canvas, 20″ × 24″ (51 × 61 cm), collection the artist. In this charming period piece, the tonal gradations of the sky and beach are painted in creamy color, softly blended. Semitransparent scumbles create the smoke and mist on the distant cliffs. Drybrush and scumbling convey the texture of the stone buildings and steps at the left.

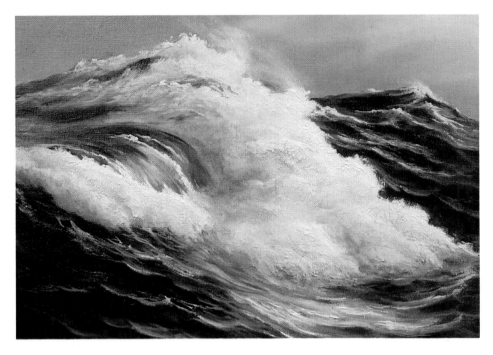

Heavy Seas (detail) by James Gray, ASMA, alkyd on canvas, collection Winsor & Newton, © James Gray. The artist piles alkyd color thickly onto the canvas with coarse, irregular strokes to convey the texture of the foam. Thin, fluid strokes render the slender foam trails that move rhythmically over the water. Oleopasto is a heavy gel medium that's especially suited to the kind of impasto effects that you see here.

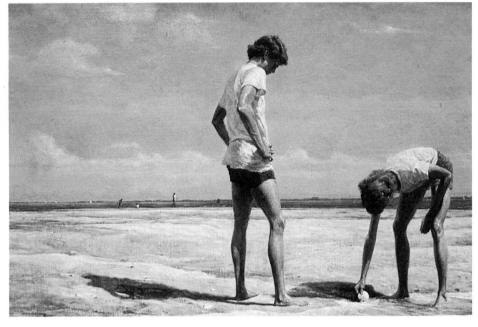

Morehead 1978 (detail) by R. B. Dance, alkyd on canvas, collection Mr. and Mrs. Eldridge C. Hanes. Dance takes full advantage of transparent glazes and semitransparent scumbles in this light-filled, atmospheric landscape with two figures (both posed by the artist's son Scott). He follows the old-master technique of painting the shadows with thin, relatively transparent color, while he develops the halftones with semitransparent scumbles, and gradually builds up the lights with thicker, semiopaque scumbles. Opaque touches are saved for the strongest lights on the beach and the figures.

Returning by R. B. Dance, alkyd on gesso panel, 14″ × 21″ (36 × 53 cm), collection Dr. Larry Weiss. The murky transparency of the sea is one of nature's most challenging and difficult color effects—which Dance captures by the gradual application of multiple glazes. He applies as many as thirty glazes in such paintings, waiting overnight for each glaze to dry before he brushes on the next layer of color. He considers skies almost as difficult as water and paints them in a similar way. Here, the sky combines multiple glazes and scumbles. A Dance seascape is like a series of layers of colored glass.

Boathouse Floor by Robert Vickrey, alkyd on gesso panel, 20″ × 24″ (51 × 61 cm), collection the artist. Photo by Tim Schroeder. Best known as a modern master of the ancient medium of egg tempera, Vickrey turns to the new medium of alkyd when he's planning a picture that requires fast-drying color that still allows time for subtle blending of tones. As he does in tempera, he works with small strokes, gradually building the forms, lights, and shadows with small, soft-hair brushes. But, unlike tempera, each touch of alkyd color merges softly with the surrounding tones. The rich tone of the shadows is a particularly fascinating example of this technique: the shadows are actually an optical mixture of warm and cool touches that merge into a delicate mosaic of strokes that are almost invisible. The artist reserves his most sharply defined brushwork for the boy's hair, which is executed with crisp, curving strokes.

Brushes. If you're already working in oil, you can work with any brushes you'd use for oil painting—hog-bristle, sable, ox-hair, nylon—and the same knives too. If you're buying brushes, always buy the best and biggest you can afford; big brushes encourage vigorous brushwork. The more brushes the better, of course, but here's a good starter set, containing just nine. Buy three really big bristle brushes, around 1″ (25 mm) wide for painting big areas. Try three different shapes: a flat, a filbert, and a bright. Then get three more bristles about half this size—in the same three shapes. For painting smoother passages and for drawing lines and details, you'll need three softer brushes—sables or the less expensive nylons: one that's about 1/2″ (12 mm) wide; another that's half as wide; and a pointed round brush that's roughly 1/8″ or 3/16″ (3–5 mm) thick at its widest place.

Knives. A palette knife is indispensable for scraping wet color off the canvas or the palette. The trowel shape (rather than the straight blade) is best for mixing colors because it's designed to keep your knuckles away from the palette. To *paint* with a knife, buy one or more painting knives with specially designed, flexible, diamond-shaped blades.

Painting Surfaces. While you're still experimenting with alkyd, canvas boards are convenient and inexpensive. But once you start to paint seriously, switch to stretched canvas—linen or cotton—or work on hardboard or seasoned plywood panels coated with acrylic gesso. You may also enjoy working on rag paper that's isolated with highly diluted shellac, acrylic medium, or acrylic gesso.

Easel. Your oil painting easel—if you already have one—is equally good for alkyd painting. But if you have to save some money, it's easy to improvise various kinds of "easels." Some professionals just tack canvas or paper on a well-lit wall. For panels or stretched canvases, you can hitch an adjustable shelf to that same wall. And lids of most paint boxes are grooved to hold a canvas board so that the upright lid can be transformed into an easel.

Paint Box. The traditional wooden paint box, with its many compartments of different sizes and shapes, will store or carry practically all the gear you need for alkyd painting. There are spaces for tubes of color and medium, bottles of medium and solvent, brushes and knives, and various accessories. And the lid will often hold two or three canvas boards. However, the paint box is most useful for painting on location. If you normally work indoors, you can save the cost of a paint box by storing your gear in an old toolbox or fishing-tackle box. Or you can just divide an empty drawer into compartments with strips of cardboard.

Palette. Provided that you scrape the surface methodically and wipe it absolutely clean at the end of each working day, you can use a traditional wooden palette for alkyd painting. But if you let alkyd color dry overnight on a wooden palette, you're asking for a headache. It's a chore to scrape off the dried color. A powerful industrial solvent will work, but such toxic solvents don't belong in the studio. For most artists, a paper palette is more convenient. This is just a pad of nonabsorbent paper with pages that you can tear off at the end of the day. Since you can't save alkyd colors overnight, squeeze out a small supply on the paper palette; then toss away the top sheet and the paint residue at the end of the painting session.

Accessories. To hold your Liquin medium and solvent, buy a double palette cup—called a double dipper in Britain. Some sticks of natural charcoal are good for sketching the lines of the composition on the canvas. (Don't use charcoal pencils or compressed charcoal; the lines are harder to dust off.) Smooth, lint-free rags are best for wiping mistakes off the painting surface. Paper towels are useful for wiping paint off your brush as you work. A stack of old newspapers is best for wiping your brush after you rinse it in solvent. When you feel ready to stretch your own canvas, buy a good, well-balanced hammer (preferably with a magnetic head), some non-rusting carpet tacks or slender nails about 3/8″ (9–10 mm) long, a heavy scissors, and an L-square that can function as a ruler and also check that your corners are properly squared up. And if you're headed outdoors, don't forget a hat, suntan lotion, and insect repellent!

Canvas. Art supply stores normally sell two kinds of canvas: cotton and linen. You can buy either kind already stretched—mounted on a wooden framework—or by the yard if you want to stretch it yourself. Both are equally suitable for alkyd painting. Cotton is usually less costly, but it tends to have an even, mechanical grain that's less interesting than linen, which has a more irregular surface—more "personality." So try linen canvas when your budget permits.

Preparing Your Own Canvas. Linen canvas has even more individuality when you prepare it yourself. Instead of buying canvas that's pre-coated with a white primer, you buy "raw" (unprimed) canvas. After stretching the un-primed canvas, you brush on two coats of animal hide glue (such as rabbit skin glue) to seal the surface so that the absorbent fibers won't soak the binder out of the paint layer that comes next. This glue size is allowed to dry—and the raw canvas shrinks tight as a drum. Then you brush on one or two priming coats of white lead oil color (the kind made with linseed oil) or an oil painting primer made by a good art supply manufacturer. Professionals often size and prime their own canvas because the process gives them complete control over the texture of the painting surface. The bare canvas itself carries the artist's own distinctive brushwork.

Panels. If you prefer to paint on a smooth, rigid support, try hardboard or thoroughly sea-soned plywood coated with gesso. Ready-made gesso panels are hard to find in most art supply stores, but ask your local store owner if he can track down some panels for you. If not, it's not hard to make your own. It's no longer essential to cook up traditional gesso—hide glue and white pigment—in a double boiler, though some artists still prefer the old formula. Ready-made acrylic gesso, sold in most art supply stores, is fine for panels and can be applied without a preliminary coat of size. Thinned with water to the consistency of coffee cream, acrylic gesso will produce a smooth, even coat. Applied more thickly—diluted with less water—the gesso will retain the marks of the big brush you use to apply it. And if you apply two thick coats of white gesso, with the strokes of the first coat running from top to bottom and the strokes of

the second coat running from right to left, the crisscrossed brush marks will form a pattern that resembles canvas.

Paper and Illustration Board. Diluted with Liquin medium and solvent to a fluid consist-ency—similar to that of watercolor, gouache, or acrylic—alkyd flows beautifully on sturdy paper or illustration board. It's worthwhile to try al-kyd on top-quality watercolor paper, which is highly durable if the picture is exhibited under glass. But, like raw canvas, the paper is absor-bent and must be sized (or isolated) to keep it from soaking up the alkyd resin from the paint. A very thin coat of shellac (with lots of alcohol) or acrylic medium (with lots of water) will do the job. So will a thin coat of acrylic gesso, diluted with water to the consistency of milk so that the gesso won't be thick enough to obscure the texture of the paper. Illustration board is an interesting compromise because it's almost as rigid as a panel, yet it comes in various textures, since the boards are faced with a va-riety of papers that range from smooth drawing paper to rough watercolor paper. (The latter are usually called watercolor boards.) The pa-per surfaces of these boards must also be isolated with thin shellac, acrylic medium, or acrylic gesso. But bear in mind that such boards are usually backed with a thick gray layer of perishable paper that will deteriorate with time. If you want to paint absolutely per-manent pictures on paper, it's wise to stay with the best watercolor stock.

Other Surfaces. Like oil and acrylic, alkyd will adhere to many other surfaces that artists have tried over the centuries. Any durable fabric—such as the muslin used by some old masters or the silk used by the Chinese masters—is a re-ceptive surface for alkyd, provided that the cloth is bonded to hardboard or plywood with hide glue or acrylic medium and then isolated in the same way as paper. And alkyd will adhere to plaster or metal. A polished surface should be roughened first with fine steel wool or a fine grade of abrasive paper. And plaster should first be made nonabsorbent with a coat of glue size or acrylic gesso. Alkyd, like oil and acrylic, won't adhere well to slick, glossy surfaces, so avoid materials such as shiny plastic or wood that's waxed or lacquered.

Canvas. The weave of cotton or linen canvas—or even the inexpensive canvas on a canvas board—has a distinct influence on the texture of an alkyd painting, just as it does on an oil or acrylic painting. The canvas softens the brush stroke, as you see here. A stroke on canvas has a characteristically soft edge, like the strokes of the foreground foliage in this section of the painting in Demonstration 7. This quality of canvas makes this painting surface most effective for subjects that require soft blending.

Panel. Brush strokes are usually more distinct on the smoother surface of a panel. The most widely used panel material is hardboard coated with acrylic gesso. When the gesso is applied in a series of very thin coats, the panel has virtually no texture. But many artists prefer to apply the gesso more thickly so that the painting surface shows the marks of the brush that carries the gesso, as you see in this picture. Here strokes of alkyd color are more sharply defined than they are on the canvas, but the brushwork is still broken up and animated by the delicate grooves in the gesso. Panels are the favorite painting surfaces of painters who favor crisp brush-work—like the stems and leaves in this detail from a still life—and the sharp-focus realists who need a smooth surface that encourages precision.

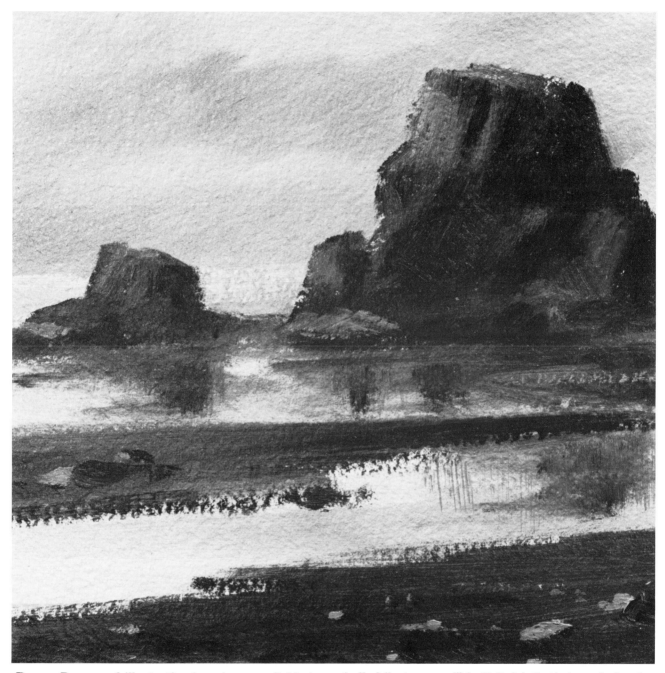

Paper. Paper and illustration board are available in a great variety of interesting textures that are worth trying for alkyd painting. To make a sheet of paper or illustration board suitable for alkyd, all you need is a thin coat of acrylic gesso to make the surface nonabsorbent. This is a detail from Demonstration 4, painted on cold-pressed watercolor paper (called "not pressed" in Britain) that's been isolated with gesso. The slightly ragged texture of the hand-made paper breaks up and enlivens the brush strokes—and the surface of the painting resembles a watercolor. For a smooth painting surface, try gesso-coated illustration board, which responds to the brush in a way that's similar to a gesso panel.

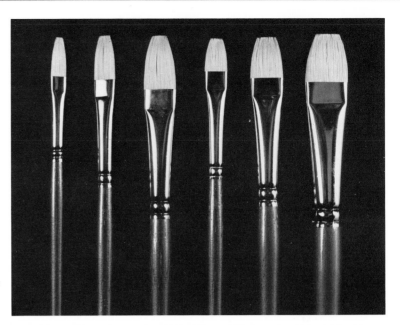

Bristle Flats and Brights. All the standard oil painting brushes will work just as well with alkyd colors. The most popular bristle brushes are flats and brights. The three at the left are flats: long, slender brushes that taper to a squarish tip. The three at the right are brights: shorter and stiffer than the flats. The long, resilient flats are especially good for loose, casual brushwork. The stiffer brights will carry a heavier load of color and leave a more strongly textured stroke.

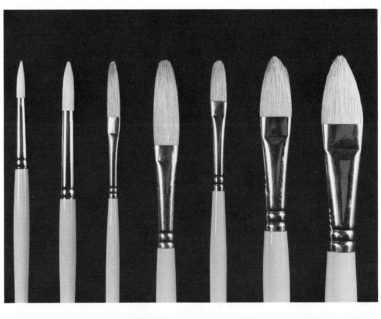

Bristle Rounds and Filberts. Two other kinds of bristle brushes are particularly useful for painting in alkyd when it's diluted to a creamy or semiliquid consistency. The two brushes at the left are round bristle brushes, the shape favored by the old masters, whose paint was generally more fluid than modern tube colors. A splendid compromise between the round and flat shapes is the filbert—whose varied shapes are represented by the other five brushes in this photograph. The filbert is a flat brush that tapers to a rounded tip. Filberts come in many different lengths, shapes, and sizes, all springy and excellent for loose brushwork with fluid color.

Soft-Hair Flats. Soft-hair brushes are best for very smooth passages of creamy or liquid color, and for softly blended gradations. They're especially effective on the smooth surface of a gesso-primed panel or illustration board. The two brushes in the center are filberts. The others are the standard square shape. The brushes shown here are expensive sables—the best soft-hair brushes—but less expensive ox-hairs will do the job if you're on a budget.

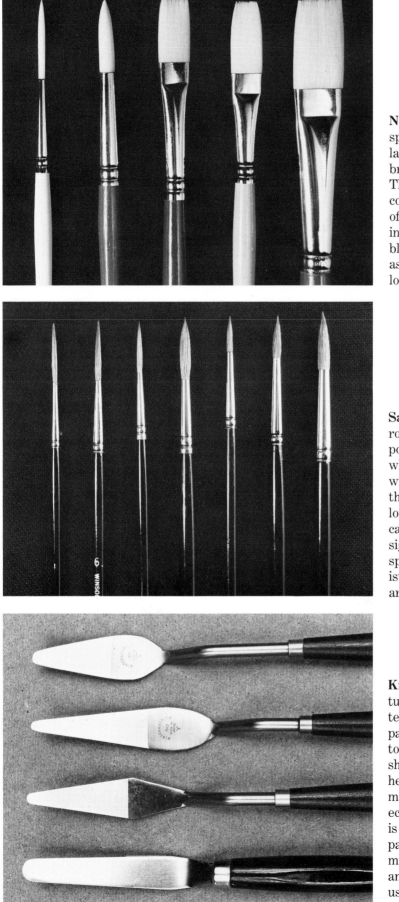

Nylon Rounds and Flats. Soft, yet springy white nylon brushes are also popular for alkyd painting. They're softer than bristle brushes but a bit stiffer than sables. They're best for smooth brushwork with color that's been softened by adding a lot of painting medium. Thus, they provide an inexpensive alternative to the costly sables. Yet they can also perform somewhat as bristle rounds and filberts do, with loose, fluid strokes.

Sable Rounds. For precision painting, round sables are the favorites. Their sharp points will execute the most exact details, while the full bodies of the bigger sables will carry enough fluid color for strokes that are both bold and controlled. The two long brushes at the left are a special shape called a scriptliner, originally developed for sign painting but favored by artists for sprightly, rhythmic line work. (For the artist on a budget, the round nylon brushes are an efficient and less costly alternative.)

Knives. Blended with gel medium, alkyd tube colors have a solid yet soft consistency that's ideal for knife painting. The painting knife is a surprisingly versatile tool, coming in a variety of sizes and shapes, such as the top three knives shown here. The side of the blade is designed to make broad strokes, while the tip will execute accents and details. The bottom knife is a palette knife, designed for scraping paint off the canvas or the palette, and for mixing colors. The sturdy palette knife is an essential tool, but it should never be used for painting, which is the job of the delicate, springy painting knives.

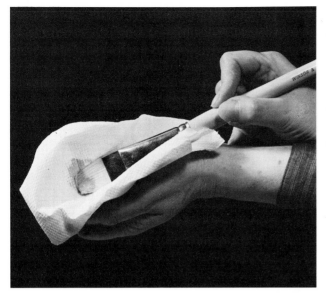

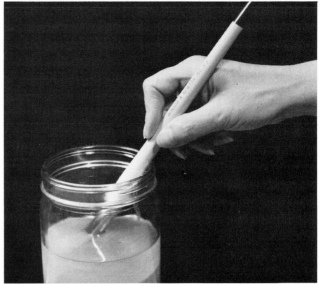

Step 1. To get the best performance—and the longest life—out of your brushes, you *must* get into the habit of cleaning them properly at the end of each painting session. Begin by wiping the brush with a paper towel (or any absorbent scrap paper) to remove any thick accumulated paint.

Step 2. Now rinse the brush in a jar of solvent: turpentine, mineral spirits, white spirit, rectified petroleum, etc. Swirl the brush around in the jar until all the thick paint has been dissolved and rinsed away. At this point, all the *loose* color is dissolved in the muddy-looking solvent, but the bristles are still discolored by a thin film. (By the way, don't forget to *rinse your brush frequently as you paint* so that the alkyd color won't begin to dry on the bristles.)

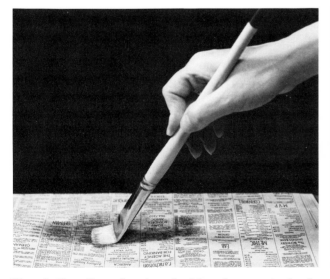

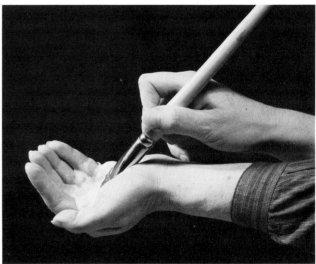

Step 3. Dry the solvent-soaked brush on a stack of old newspapers or any other absorbent waste paper. Just move the brush back and forth over the paper—as if you're painting—until most of the solvent is gone. By now, the bristles are damp, not sopping wet, but they still carry a thin film of solvent and a last trace of color.

Step 4. To complete the cleaning job, coat the palm of your hand with a mild white soap (not harsh laundry soap) and lather the brush in your hand. Move the brush with a circular motion, pressing down firmly so that the lather can work its way far up into the bristles. Rinse in lukewarm or cool water. Repeat the lathering and rinsing process until the lather is snow-white. The bristles may retain a very slight stain, but the white lather means that you've removed all the color that will come out. The brush is clean.

Mixing with the Brush. When you mix alkyd colors with the brush, you follow the same "rules" you follow with oil paint. Always use the central area of the palette for mixing so that you don't foul the fresh tube colors that you've squeezed out along the edges of the palette. Wipe or rinse your brush frequently in solvent (and dry it on a newspaper) to keep your color fresh. Plan each mixture beforehand, so you don't poke your brush into various colors at random, hoping that the right mixture will happen by itself. Try to limit each mixture to no more than three colors—plus white—to keep your mixtures bright and clear. And avoid overmixing: as soon as the mixture looks right, stop stirring it around. The less stirring you do, the brighter your colors will look.

Adding Solvent. One of your two palette cups (or dippers) is for solvent, which means turpentine or petroleum solvent. The quickest way to thin your dense tube color is with a drop or two of solvent, picked up on the tip of your brush and blended with the color in the mixing area of your palette. It's *possible* to paint with nothing more than solvent and tube color. The solvent does make the thick color more fluid, but there are still better ways to improve the brushing qualities of your color.

Adding Medium. The other palette cup (or dipper) is for Liquin painting medium, which is actually a blend of alkyd resin and solvent with a consistency something like that of warm honey. Working with medium in one cup and solvent in the other, you have much more control over the brushing qualities of your color. By adding just a few drops of medium—picked up on the tip of a clean brush and blended with tube color in the center of the palette—you can produce a consistency like that of soft butter. As you add more medium, or a blend of medium and solvent, you can create a consistency that ranges from that of thick cream to skim milk, depending upon the *proportions* of medium and solvent. You can also add one of the two gel mediums instead of Liquin. The lightweight Win-Gel, added to your tube color with a brush or a knife, converts the dense tube color into a soft paste that will brush out smoothly *or* stand up from the painting surface if you work with thick brushstrokes. The heavier gel, Oleopasto, will soften your tube color to just the right consistency for thick brush and

knife strokes. And you can make any mixture of gel and tube color just a bit softer by adding a touch of solvent, of course. By adding medium, with or without solvent, you're softening your tube colors by adding more of the alkyd binder that was used to manufacture the color in the first place. Thus, even when the mixture is a thin, transparent glaze, the paint has a rich, juicy feeling that's hard to get by adding solvent alone.

Mixing with the Knife. Try mixing with your palette knife—instead of a brush—and you'll make the discovery that the purest mixtures are made with the knife blade. To produce bright, clear color, follow a few "rules." Pick up fresh color on the underside of the knife blade. Deposit the color in the central mixing area of the palette. Then wipe the blade absolutely clean with a paper towel or a rag before you pick up each new color and add it to the mixture. Blend the colors by spreading the mixture outward, holding the blade flat against the palette and moving either from side to side or with a circular motion. When the color is spread out, heap it up with the edge of the blade and then spread it out again—repeating this process until the blending operation is done. Don't always blend your colors thoroughly. Sometimes a mixture is more fascinating if the colors are just partially blended.

Care of Brushes and Knives. Because alkyd becomes tacky in hours and dry overnight, it's essential to make sure that the color doesn't solidify on brushes or knives. As you work, rinse your brush frequently in solvent—not the solvent in the palette cup, of course, but a big jar of solvent kept near the palette on your work table. After a while, the solvent in the jar will look like mud. To prevent this muddy fluid from getting into your color mixtures, always wipe your brush on newspaper after rinsing. When you dip your brush into wet color or medium, try to work with the tip of the brush and avoid getting color into the back end, where the hairs are gripped by the metal tube called the ferrule. Too much color back there will stiffen the brush. Knife blades, like brushes, should be cleaned often while you work. Wipe the blade with a cloth or paper towel, moistened with solvent if the color is starting to harden.

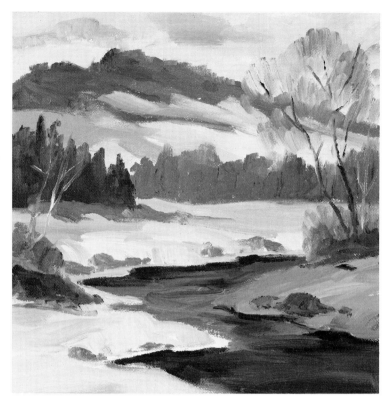

Broad Strokes. This winter landscape is painted mainly with broad bristle brushes—both flats and brights—that leave wide, squarish strokes on the painting surface.

Broad Strokes (detail). Here's a close-up of the central section of the painting reproduced above. You can see that the distant grove of trees (at the top) is painted with short, thick vertical strokes that merge to create an irregular mass of tone that retains the marks of the brush. The snow is executed with sweeping horizontal strokes that curve just a bit to suggest the slightly rounded shape of the snowy shore line. The water is also done with broad strokes, but the color is thinner and the brushwork more casual and irregular to suggest the moving water.

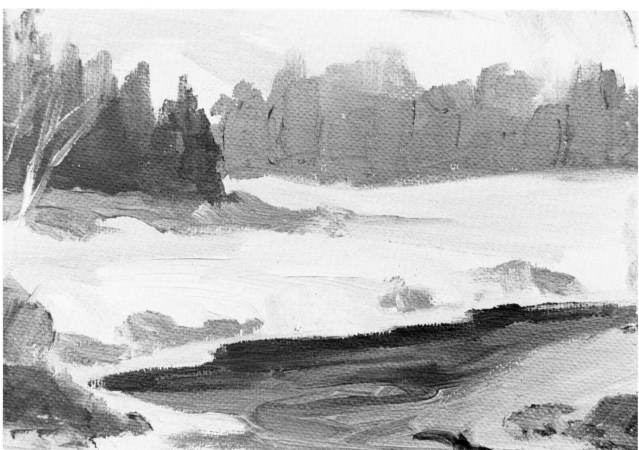

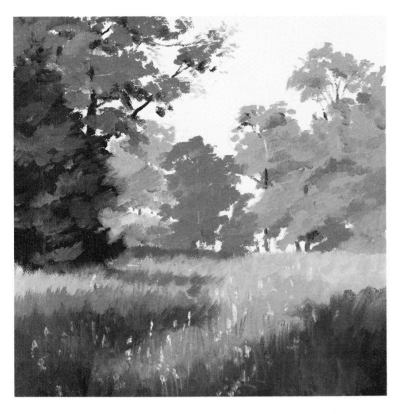

Short Strokes. Painted with a kind of brushwork that reminds us of the Impressionists, the trees and grasses of this summer landscape are built up with short strokes that are made by the tip of a small bristle brush.

Short Strokes (detail). In this enlarged close-up of the foliage at the very top of the painting, you can see the small, ragged touches of the brush more clearly. The soft-edged, slightly rounded brush strokes are typical of the bristle brush called a filbert—a long, resilient brush that tapers to a rounded tip. The texture and detail of the foliage are suggested by touching the brush to the canvas again and again, gradually building up the pattern of strokes until they look like masses of leaves. Then, for the trunks and branches, the artist draws a few long, gently curved strokes. The long, springy filbert makes the branches look springy.

Slender Strokes. The dense mass of weeds in the foreground is painted with long, curving strokes made by a slender bristle brush and an even thinner soft-hair brush.

Slender Strokes (detail). As you study this close-up of the weeds, you can see how the two brushes are used. First, a long slender bristle brush—either a filbert or an old, ragged flat—paints the dark overall tone of the foliage with long, curving movements. The color is highly diluted and soon becomes tacky. The artist then picks up a sharply pointed, round sable brush to paint the details with liquid color, right over the tacky undertone. The tip of the round brush draws dark stalks among the weeds and carries the strokes up to suggest a few weeds silhouetted against the pale water. Then, lower down, the soft-hair brush adds lighter strokes to suggest weeds (and a few wild flowers) caught in sunlight.

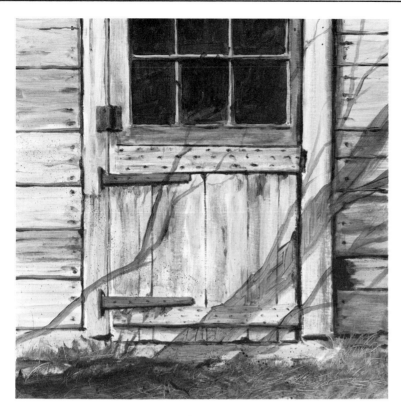

Fluid Color. To capture the texture of this weathered wooden door and the surrounding walls, the artist uses bristle brushes and highly diluted color.

Fluid Color (detail). This close-up of the door shows how the stiff bristle brushes, carrying just a small quantity of fluid color, paint the door with scrubby strokes that retain the imprint of the bristles. The marks of the bristles convey the texture of the wood. Even the shadows of the trees on the door show this same texture. The picture is painted on a gesso panel whose surface enhances the effect. The gesso is slightly rough, retaining the marks of the gesso brush. Thus, the texture of the panel roughens the artist's brushwork. Notice how the direction of the stroke follows the grain of the wood: horizontal boards are painted with horizontal strokes, while vertical boards are painted with vertical strokes.

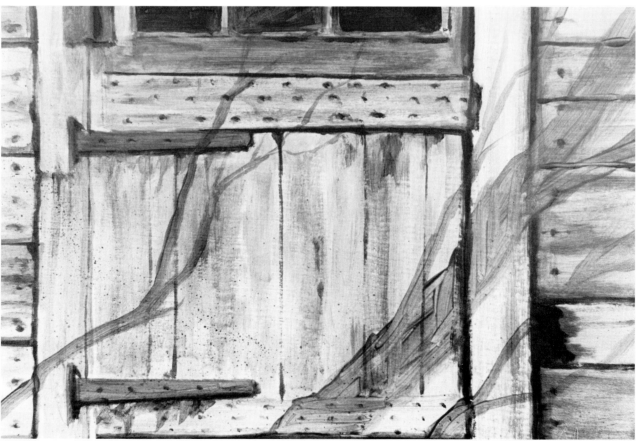

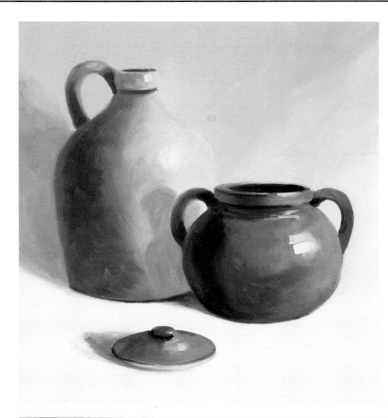

Smooth Blending. Diluted with liquid painting medium (Liquin) or lightweight gel medium (Win-Gel), alkyd can be softly blended to create smooth, luminous gradations such as those you see on the rounded forms of these ceramic vessels.

Smooth Blending (detail). Examining the brushwork closely, you see that the blending is done with a flat soft-hair brush, and that the painting is on a smooth gesso panel whose surface complements the polished surfaces of the ceramics. The brush strokes tend to curve in order to follow—and emphasize—the rounded forms. Notice how the artist blends the strokes to fuse the lights, halftones, and shadows, but he doesn't obliterate the strokes entirely. The marks of the brush are unobtrusive, but still there, lending vitality to the finished painting.

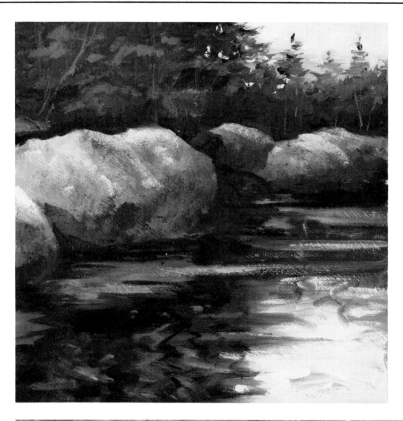

Scumbling. As you already know, a scumble is a semitransparent mist of color—in contrast with a glaze, which is a clear, transparent layer of color. But there's a way of handling the brush that's also called scumbling because the movement of the brush creates a thin, scrubby veil of semitransparent color. That's how the lighter tones on these rocks and water are done.

Scumbling (detail). The scumbling stroke is a back-and-forth scrubbing motion that spreads the color in a thin, irregular veil that allows some of the underlying color to show through. Thus, the lighted tops of the rocks are scumbled to allow some of the underlying darker tone to appear through the scumble. In the same way, the dark undertone of the water shines through the scumbled streaks and patches of light on the shining surface.

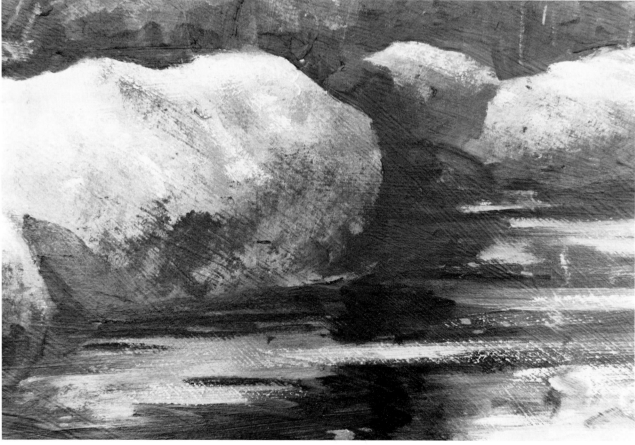

Starting to Paint with Alkyd. Once you've gone out and bought your first set of alkyd colors and mediums, the big question is what to do next. The best way to discover the technical possibilities of any new painting material is to plan a series of painting projects. In the next thirty-two pages, the noted painter Ferdinand Petrie demonstrates, step by step, eight different ways to work in alkyd. The quickest and most enjoyable way for you to learn what alkyd can do is to try each of these eight methods for yourself. Study Ferdinand Petrie's demonstrations—examining each step as if you're in the artist's studio, watching over his shoulder as he paints—and then find a similar subject so you can test out the process you've just seen.

Direct Painting. In Demonstration 1, the artist shows the simplest of all techniques: direct or *alla prima* painting. This means aiming for the final effect right away, from the very beginning. After a preliminary brush drawing on the canvas, he moves in with solid strokes of the final colors that will appear in the completed painting. The picture is finished in one continuous working session: a morning or an afternoon—perhaps a full day, but no more. The artist doesn't wait for the colors to dry, but keeps working on the wet (or tacky) painting until it's done.

Direct Painting over Tonal Washes. Demonstration 2 shows a slightly more complex version of the direct technique. The artist begins with a tonal sketch of his subject—indicating the distribution of light and shadow—in washes of alkyd thinned with solvent to the consistency of watercolor. This sketch is dry to the touch in minutes. Over the sketch, he works with strokes of heavier color, diluted with Liquin, aiming for the final effect in a single working session, as in the previous demonstration.

Direct Painting over Color Washes. Still another direct technique is shown in Demonstration 3. Over the preliminary brush drawing, the artist washes a hint of fluid color (with lots of solvent) to create a muted color sketch. As soon as the solvent evaporates and the sketch is dry to the touch, he follows the sketch as a guide and covers the picture with thick strokes

of solid color blended with Win-Gel medium and a few drops of solvent for thinner passages.

Direct Painting in Fluid Color. Alkyd can be used as thinly as acrylic or gouache, as the artist shows in Demonstration 4. Now he builds up the entire painting with washes of fluid color, diluted with solvent and Liquin to a milky consistency. Once again, the picture is completed *alla prima*—in one session.

Sharp-Focus Technique. Demonstration 5 shows a direct technique that's unique to alkyd. The artist begins by covering the major shapes with broad, fluid masses of color diluted with Liquin and lots of solvent that evaporates swiftly. These first tones are soon tacky. Then, working with small brushes and fluid color, he completes the picture, building up sharp-focus detail with intricate strokes. This technique is impossible in oil.

Monochrome Underpainting. Now the artist shows the simplest of the multiple-step techniques used by the old masters. Choosing a subject that requires careful drawing and very accurate rendering of light and shade, he paints Demonstration 6 in a warm monochrome diluted with Liquin and solvent. When this underpainting is allowed to dry overnight, he completes the painting with colorful glazes, thinned to transparency with Liquin and brushed over the first layer.

Color Underpainting. Exploring another old-master technique in Demonstration 7, the artist begins with an underpainting in color, letting the first layer dry overnight. Over the dry underpainting, he brushes transparent glazes and semitransparent scumbles. The underpainting and overpainting mix in the viewer's eye, like multiple layers of stained glass, to create magical optical mixtures.

Textured Underpainting. The artist finishes his survey of underpainting and overpainting methods with Demonstration 8, showing how to do a roughly textured underpainting in thick color blended with the heavy gel medium, Oleopasto. When these thick strokes are dry, he completes the picture with thinner strokes that are animated by the dramatic textures of the underlying brush and knife strokes.

Step 1. This first demonstration shows the simplest alkyd painting method—the direct technique, which means aiming for the final colors from the very beginning. The artist starts with a brush drawing on the canvas, indicating the main shapes with a mixture of ultramarine blue, burnt sienna, and white, diluted to a fluid consistency with lots of solvent. He draws lines within the rocks to show the planes of light and shadow—the sunlit top planes and the darker side planes that don't receive the direct sun. The drawing is done with a round soft-hair brush.

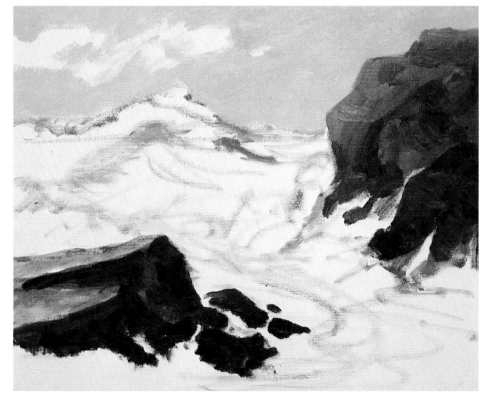

Step 2. Switching to broad bristle brushes, the artist blocks in the dark side planes of the rocks with big strokes of ultramarine blue and burnt sienna. He lays in the warm top planes with ivory black, burnt sienna, cadmium yellow, and white. He covers the sky with ultramarine blue, alizarin crimson, and lots of white, leaving a patch of bare canvas for the lighted top of the cloud formation. All the colors are now diluted with Liquin and solvent to a creamy consistency.

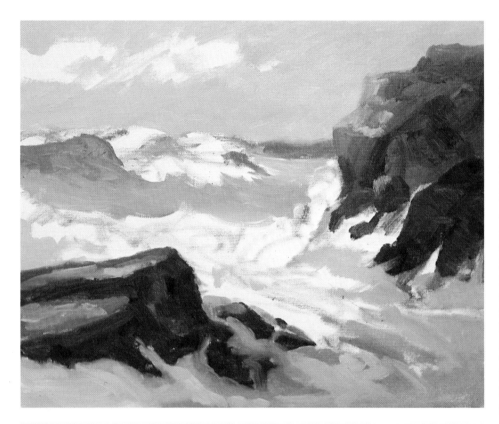

Step 3. The artist continues to build up the sunlit planes of the rocks with burnt sienna, cadmium yellow, a hint of ultramarine blue, and white. He covers the cool face of the oncoming wave with a blend of ultramarine blue, viridian, yellow ochre, and white—with more blue at the top of the wave and more yellow at the bottom. The cool shadow on the foam in the foreground is ultramarine blue, alizarin crimson, a speck of burnt umber, and white—with a bit more blue in the darks. The artist is still working with big bristle brushes, and he's diluting his mixtures with Liquin and solvent.

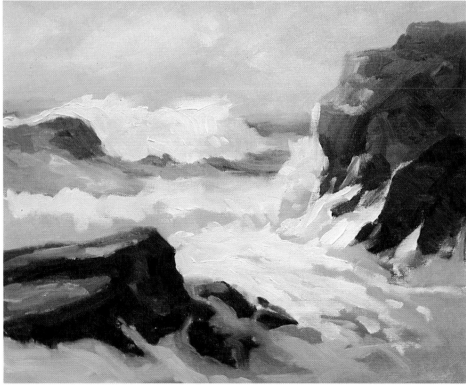

Step 4. The artist brushes in the lighted areas of the clouds with white and yellow ochre. He then blends the sky strokes to produce a more even tone. He darkens the oncoming wave with strokes of the original mixture—plus more blue. Now he begins to block in the sunlit foam with thick strokes of white, yellow ochre, and a hint of the foam mixture that first appears in Step 3. These thick strokes are diluted only with Liquin and applied with short, stiff bristle brushes that carry lots of thick paint.

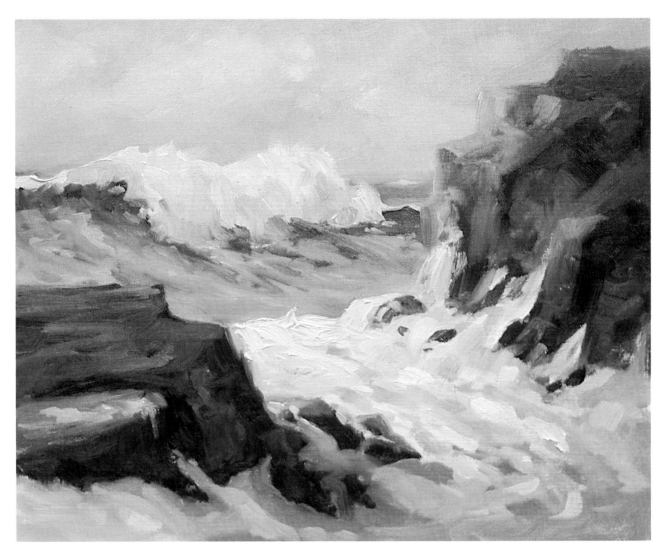

Step 5. As always, the final details and subtle adjustments are left for the last stage—after all the broad masses of color are on the canvas. Now the artist works with smaller bristle brushes and dilutes his tube color with Liquin alone, since he wants a thicker consistency. He builds up the shadows and the sunlit top of the big wave, letting his strokes show clearly to suggest the details of the foam. Using the shadowy foam mixture, he carries the tip of the brush down over the face of the wave to suggest foam trails. Thick, distinct strokes of white and yellow ochre suggest the flashing sunlight on the foam that surges between the rocks. Finally, the artist makes important adjustments in the shapes and colors of the rocks. He enlarges the rock at the left with horizontal strokes of ivory black, burnt sienna, yellow ochre, and a touch of white; the scrubby brushwork suggests the wetness of the top plane. Then he strengthens the lights on the big

rock at the right by blending strokes of yellow ochre, burnt sienna, and white into the wet color of Steps 2, 3, and 4. He adds a touch of ultramarine blue to this mixture and adds a few lighter strokes to the shadows, suggesting reflected light on the wet surface of the rock formation. The tip of a small bristle brush—a filbert—picks up yellow ochre and white, plus a tiny speck of ultramarine blue, to place such final details as the foam that trickles over the rocks in the lower left. And another small brush adds a few more dark touches at the foot of the rock formation at the right, indicating smaller rocks among the foam. The artist's sequence of operations is worth remembering. He starts with a brush drawing in fluid color; blocks in the broad color areas with big strokes of slightly thicker color; and saves the thickest color and the most precise brushwork for the final stage.

Demonstration 2

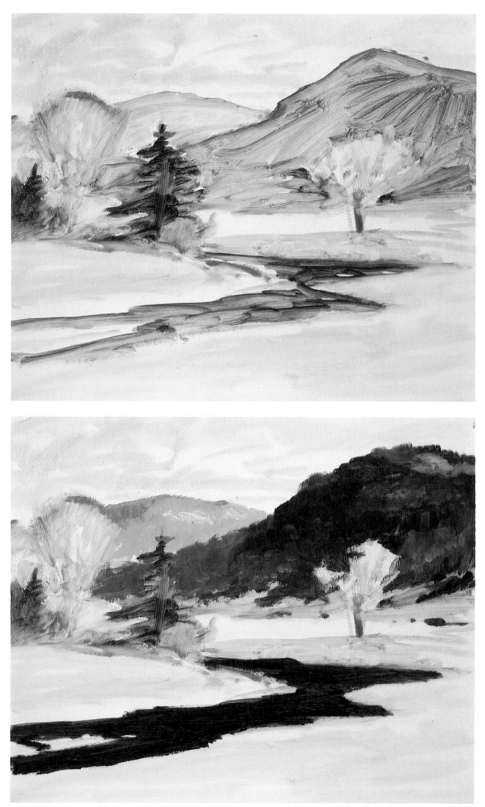

Step 1. Here's another direct technique, just a bit more complex than Demonstration 1. Once again, the artist begins with a preliminary brush drawing, but now this drawing includes a rough indication of the distribution of light and shade on the snowy landscape. To match the cool tones of the wintry subject, the artist does the brush drawing with ultramarine blue, a hint of alizarin crimson, and lots of solvent. He adds more solvent for the paler tones and less for the darker tones. The drawing is executed with a small bristle brush that covers the gesso panel swiftly with broad tonal washes.

Step 2. Working with larger bristle brushes—and diluting his color with Liquin and solvent—the artist begins to block in the broad color areas. The pale, distant mountain is painted with ultramarine blue, burnt umber, the faintest hint of cadmium red, and lots of white. The darker mountain is this same mixture with almost no white. And the dark stream, which reflects the color of the nearest mountain, is the very same mixture—but with no white at all. Notice how the artist lets his brush strokes suggest the masses of evergreens on the dark slope.

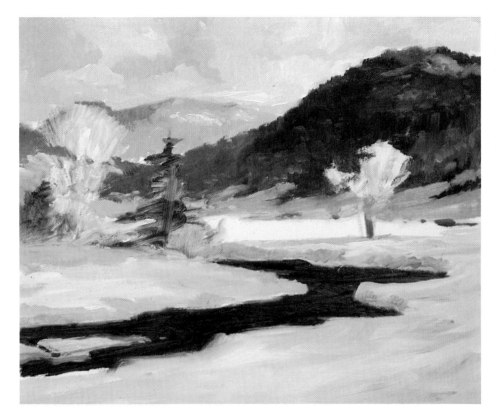

Step 3. Now the artist blocks in the darks and lights of the sky with varied mixtures of cobalt blue, alizarin crimson, a speck of yellow ochre, and white—less white in the dark areas and more in the light areas. He uses these same mixtures to render the lights and shadows on the snow, leaving a strip of bare gesso in the distance for a flash of sunlight that he expects to paint later. When you paint a winter landscape, remember that snow is *water* and reflects the sky. That's why the snow and sky are painted with the same mixtures.

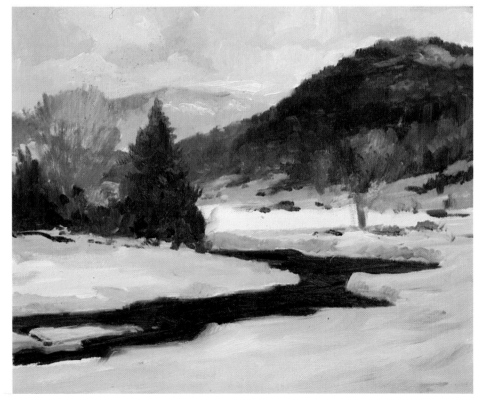

Step 4. The artist begins to brush in the tree colors, still working with bristle brushes and diluting his tube colors with Liquin and solvent. The paler foliage is cadmium yellow and ultramarine blue, with a hint of burnt umber in the shadows. The darker trees are viridian, burnt umber, and cadmium yellow. The artist also scrubs in a few clumps of dead weeds on the snow. He paints the trees with the tip of a medium-sized bristle brush, letting the strokes show clearly to suggest the masses of leaves and evergreen foliage.

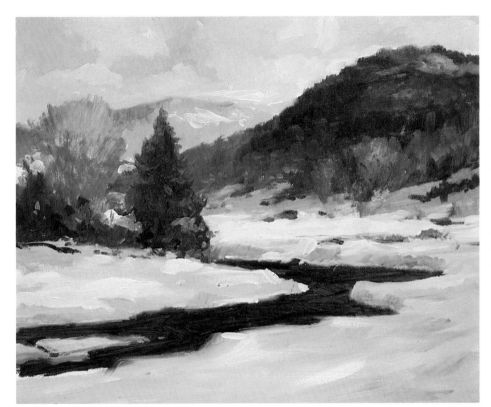

Step 5. To create the warm tone of the sunlit patches of snow, the artist blends white with a drop of cadmium yellow, and then he adds just enough Liquin to produce a thick, creamy consistency. He picks up this mixture on the tip of a medium-sized bristle brush and carries thick strokes across the foreground snow and over the strip of sunlit snow beneath the mountain. He also places touches of this sunny mixture on the pale, distant mountain and between the trees at the left.

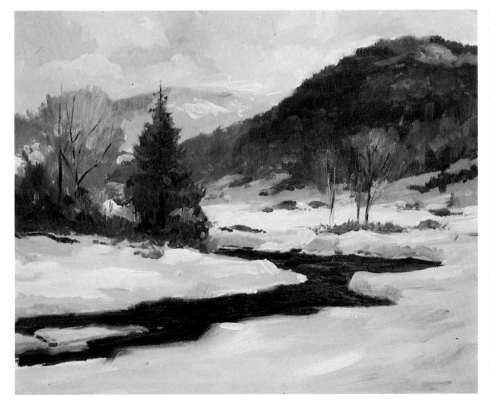

Step 6. Having covered the panel with broad masses of color, the artist can begin to think about details. He mixes a strong, dark tone by blending ultramarine blue and burnt sienna—which he makes fluid by adding Liquin and a touch of solvent. Then he uses the tip of a pointed soft-hair brush to add trunks and branches to the trees. He sharpens the detail of the weeds with a pointed soft-hair brush that carries a fluid mixture of cadmium yellow, burnt sienna, and ultramarine blue. The spiky brush strokes—on the snow beneath the trees—really look *weedy*.

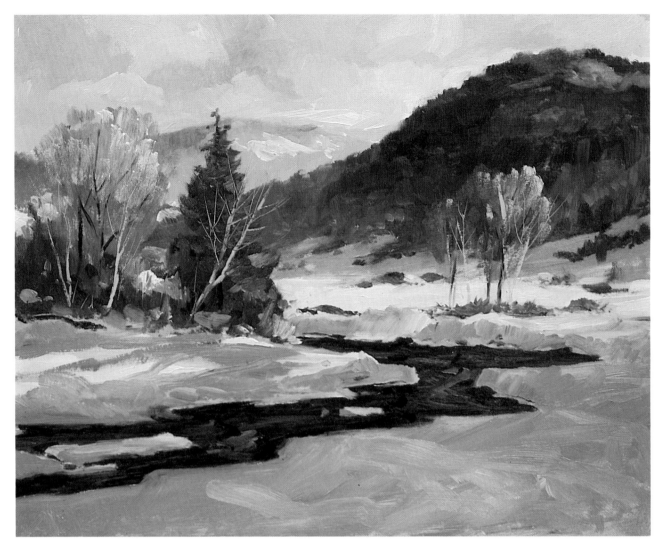

Step 7. As you've already seen in Demonstration 1, the artist saves adjustments, refinements, details, and final touches for the last stage. A small bristle brush brightens the pale foliage with distinct strokes of white tinted with cadmium yellow. The thinnest soft-hair brush adds pale tree trunks with white tinted with yellow ochre and a hint of cobalt blue. The sharp end of the wooden brush handle scratches branches into the wet paint, revealing the white gesso beneath. The artist decides to deepen the snow shadows with a darker version of the original mixture: cobalt blue, alizarin crimson, yellow ochre, and *less* white than before. Beneath the trees at the left, he draws the shadow shapes more precisely to show that the shadows are actually cast by the trees. Where the dark stream winds beneath the trees, strokes of the tree mixtures are blended into the water to suggest reflections. A small bristle brush brightens the big evergreen by blending viridian, cadmium yellow, and burnt sienna, plus a little white, into the wet, dark color of Step 4. Comparing Step 7 with Step 1, you see that the artist follows the original tonal sketch very loosely. He uses it as a guide but feels free to make changes that will improve the picture.

Demonstration 3

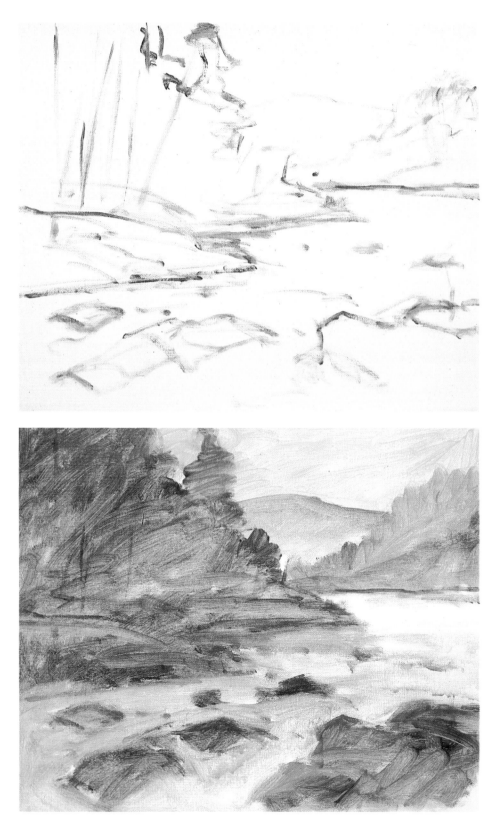

Step 1. Still another direct technique begins with a brush drawing that's actually a kind of simplified color sketch to serve as a guide for the execution of the final picture. The first step is a rough line drawing—which the artist does with a round soft-hair brush—in a mixture that will harmonize with the final colors. He sketches the main elements on the canvas with ultramarine blue and burnt sienna, diluted to a very fluid consistency with lots of solvent.

Step 2. Over the brush lines, the artist washes color that's diluted with solvent to a consistency like that of watercolor. The sky, the distant mountain, the water, and the rocks are all mixtures of ultramarine blue, burnt sienna, and alizarin crimson—in varied proportions so that some mixtures are warmer and others are cooler. The tree-covered shore on the left is viridian and burnt sienna, with a bit of yellow ochre. On the shore at the right, this mixture appears along with the sky mixture. The artist applies the color washes with a large bristle brush.

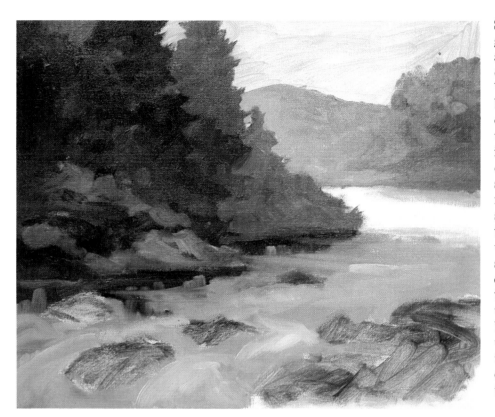

Step 3. Now the artist begins to solidify his color areas with thick strokes of tube color diluted with Win-Gel. Working with big bristle brushes, he covers the dark trees with varied mixtures of viridian, burnt sienna, yellow ochre, and white, occasionally introducing ultramarine blue to darken his strokes. Paler versions of these mixtures (with more white) appear on the shore at the right. He darkens the distant mountain and the shadowy water with ultramarine blue, burnt umber, and white—adding more blue to the mixture for the dark reflections beneath the left shore line.

Step 4. The rocks in the stream are blocked in with ultramarine blue, alizarin crimson, burnt umber, and white. This mixture appears in the rocks beneath the trees on the left shore, where the artist now blends the dark reflections into the water. For the sky, the artist turns to the more delicate cobalt blue, yellow ochre, and white, which he brushes over the color wash. He uses this pale mixture to indicate gaps where the sky shines through the trees on both shores. He works with big bristle brushes for the large rocks and sky, and smaller bristles for the small rocks and "sky holes."

Step 5. Now the entire canvas is covered with wet color—except for the light on the distant water—and so the artist begins to sharpen his shapes. With a medium-sized bristle brush, he defines the dark shapes of the foliage—on the left—more precisely, adding a few trunks. He defines the rocks and the edge of the shore with strokes of shadow. These shadowy darks are burnt umber, ultramarine blue, and ivory black. He uses the sky mixture to add more sky holes among the trees, deepening this mixture with a touch of shadow tone to suggest pale tree trunks.

Step 6. To build up the foam in the foreground, the artist blends cobalt blue, yellow ochre, and white with Win-Gel. He applies thick strokes with a medium-sized bristle brush. These strokes of pale color blend slightly with the wet, darker color beneath. As he moves back into the more distant water, the artist carefully makes his strokes smaller to suggest perspective. Now he covers the last patch of bare canvas with strokes of this lighter tone, plus some touches of the dark water mixture from Step 3, to create the patch of sunlight on the water at the river bend.

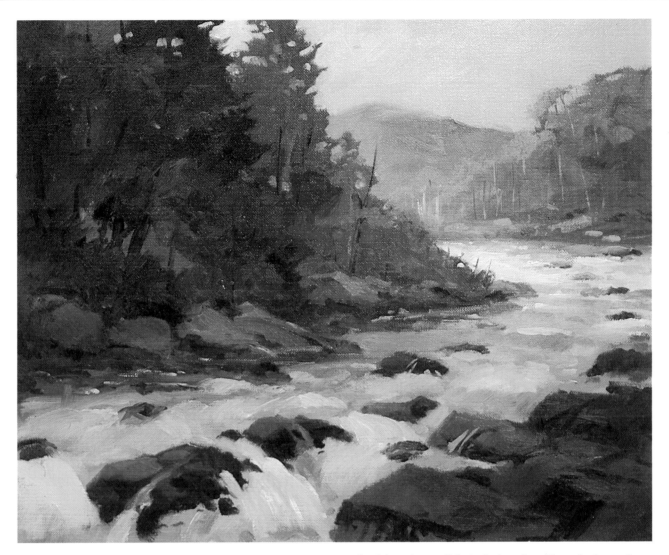

Step 7. The artist blends these touches of foam very selectively, letting most of the strokes stand out in the foreground but softening them as he moves into the distance. At the bend of the river, he builds up the light on the water with thicker strokes of the pale foam mixture, working with a small bristle brush. Small and medium-sized bristle brushes build up the shadows on the rocks with the dark mixture used in Step 5: burnt umber, ultramarine blue, and ivory black. Tiny touches of the pale foam mixture are brushed across the dark reflections at the edge of the shore to suggest glints of light on the moving water. A small round soft-hair brush picks up the dark mixture to add more trunks and branches among the trees at the left. This same brush adds pale trunks among the trees at the right with yellow ochre, burnt umber, a speck of ultramarine blue,

and white. A small bristle brush adds splashes of light to the right shore with this same pale tone. A few more details—such as trickles of foam on the rocks and several more rocks in the distant water— and the painting is complete. Because alkyd dries so swiftly when it's diluted with plenty of solvent, the tonal washes in Demonstration 2 and the color washes in Demonstration 3 are particularly effective ways to start a painting in the direct technique. The solvent evaporates in minutes, and you're ready to begin painting in the final colors. Compare the effects of the painting mediums in these two demonstrations. Demonstration 3, painted with Win-Gel, has a thicker, denser quality than Demonstration 2, which is painted with Liquin. The gel medium is thick enough for impasto painting, yet soft enough for fluid brushwork.

Demonstration 4

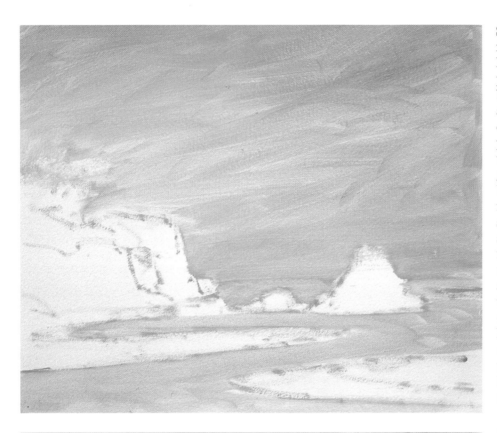

Step 1. Diluted to a very fluid consistency, alkyd lends itself to a direct painting technique resembling that of watercolor or acrylic. On a sheet of cold-pressed watercolor paper (made nonabsorbent with a thin coat of acrylic gesso), the artist does a brush drawing in ultramarine blue, alizarin crimson, white, and lots of solvent. Over this drawing he paints varied washes of these colors—adding cadmium yellow in the lower sky, and yellow ochre in the water—diluted with lots of Liquin and solvent. He works with a big bristle brush, letting the strokes show clearly.

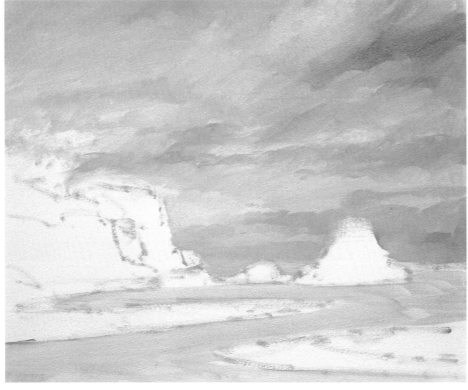

Step 2. Moving quickly while the color is still damp, the artist blocks darker tones of ultramarine blue, alizarin crimson, yellow ochre, and white into the sky. He also adds lighter tones: yellow ochre and white warmed with touches of cadmium yellow and red. The mixtures in Step 2 are slightly more opaque than those in Step 1, containing somewhat more white. But the colors are still diluted with Liquin and solvent to the consistency of watercolor or thin acrylic. Now we begin to see clouds and patches of broken light in the sky.

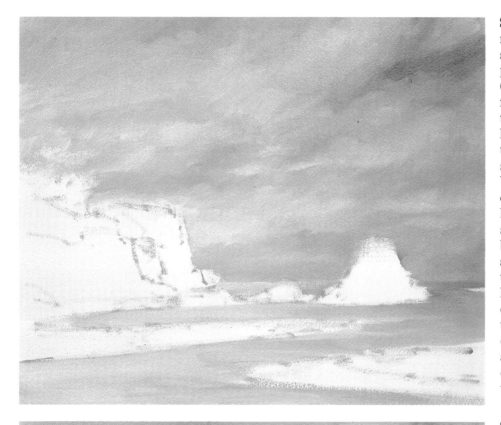

Step 3. The water at the right is darkened with the same mixture that appears in the dark clouds. (Remember that water reflects the sky.) Continuing to add the same mixtures he's been using in Step 2, the artist blends and softens the sky tones. Where the solvent has evaporated and the color has started to solidify, he simply softens it with a big bristle brush dipped in solvent. The sky now has the diffused, atmospheric look of a watercolor executed wet-in-wet. But, typical of fluid alkyd color, the brush strokes are clearly defined wherever the artist wants them to show.

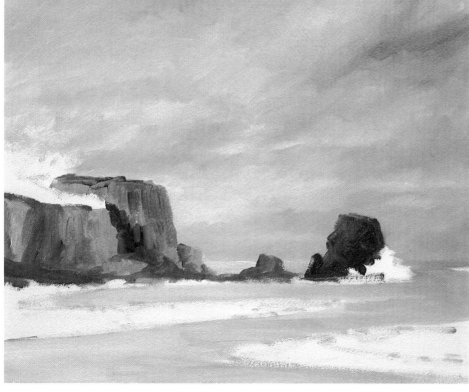

Step 4. The artist now starts to work with thicker color as he blocks in the rocky shapes with burnt sienna, ultramarine blue, yellow ochre, and white. The cool tones contain more ultramarine blue, while the warm areas have more burnt sienna—and a speck of cadmium red. To convey the blocky character and rough texture of the rocks, the artist works with short, stiff bristle brushes whose squarish strokes stand out clearly. At this stage, the color mixtures contain more Liquin and less solvent to create a consistency like that of thin cream.

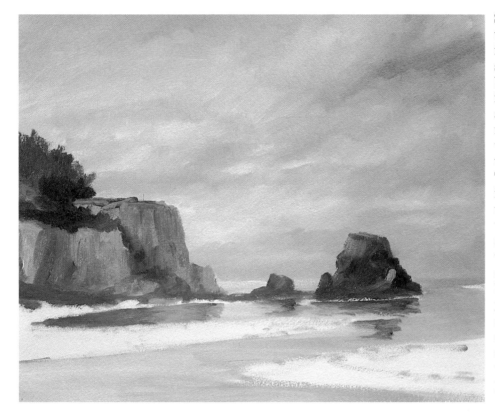

Step 5. The warm tone of the big rock at the right is completed with burnt sienna and ultramarine blue, plus cadmium yellow in the sunlit areas. The artist carries the rock mixtures down into the water to suggest reflections in the tide pools. The wiggly brush strokes in the reflections convey the movement of the water. Trees and shrubs are added to the top of the cliff with irregular strokes of ultramarine blue and cadmium yellow—with more blue and burnt umber in the shadows. The rough brush strokes, broken up by the texture of the watercolor paper, suggest foliage.

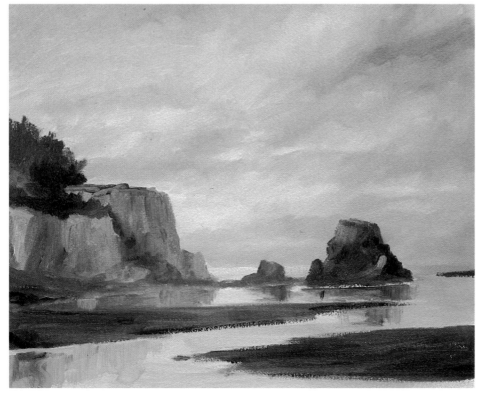

Step 6. The strips of exposed sand between the tide pools in the foreground are painted with long, horizontal strokes of ultramarine blue, cadmium yellow, and burnt sienna. The mixture is diluted with Liquin and solvent to a semiopaque consistency like that of thin cream. Along the edges of the sand, dark strokes of ultramarine blue and burnt umber are broken up by the texture of the watercolor paper to suggest shadowy tones in the rippling water. In the lower left, the cliff colors are carried farther down to create more reflections.

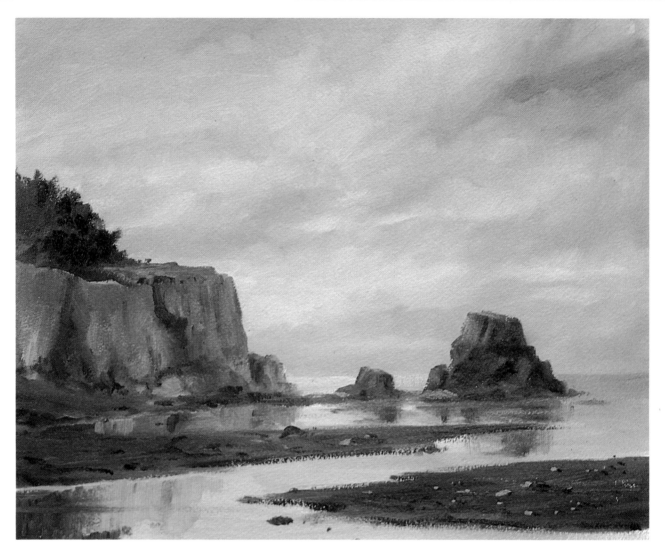

Step 7. The picture is completed with small touches of all the mixtures that the artist has used for the cliff, rocks, trees, and shrubs. Shadows are strengthened and more cracks are added to the cliff with ultramarine blue and burnt umber. Strokes of these same colors darken the reflections directly under the cliff. The shadows and details on the warm rocks at the right are also deepened with strokes of this dark mixture, which also darkens the reflections in the water below. Tiny strokes of this dark mixture are scattered across the sand to indicate pebbles and small boulders, whose sunlit tops are added with dots and dashes of white, yellow ochre, burnt umber, and ultramarine blue. Ultramarine blue and cadmium yellow are scrubbed into the lower left-hand corner to indicate the reflections of the trees in the water. The finished painting is a combination of very thin, liquid color in the sky and water, and slightly thicker but still liquid color in the rocks and sand. All the mixtures contain lots of Liquin and solvent, although the thicker strokes contain a slightly higher proportion of Liquin. By now, the sequence of brushes should be familiar: big bristle brushes in the early stages; medium-sized bristles as the artist begins to define the shapes more distinctly; and smaller bristles and soft-hair brushes for the final touches and details. By the way, it's worth mentioning that illustrators and designers often work directly on unsized paper when the painting is intended mainly for reproduction. For such purposes, alkyd tube color is diluted with pure solvent or with a blend of solvent and Liquin, and the paint can be handled like gouache or transparent watercolor.

Demonstration 5

Step 1. The unique drying cycle of alkyd colors and mediums is ideal for a technique that emphasizes sharp-focus detail, as you'll see in this demonstration. On a sheet of smooth illustration board primed with a thin coat of acrylic gesso, the artist draws the still-life objects with a slim, sharply pointed soft-hair brush that carries a fluid mixture of burnt umber and yellow ochre that has been diluted with solvent to a watercolor consistency. He indicates a few shadows. Throughout this demonstration, the artist will work with round and flat soft-hair brushes.

Step 2. The drawing is dry to the touch in minutes—as soon as the solvent evaporates—and the artist begins to block in the background. The warm tones at the left are burnt umber, yellow ochre, ultramarine blue, and white. The artist adds more white for the tone above the bucket. Then he adds alizarin crimson and more blue to the mixture for the cooler tone at the right. The shadows on the bucket are darkened with burnt umber and ultramarine blue. The colors are diluted with Liquin and lots of solvent to brush out smoothly and dry rapidly.

Step 3. While the thin color of Step 2 is drying, the artist works on the bucket. Diluting burnt sienna, yellow ochre, ultramarine blue, and white with Liquin and plenty of solvent, he washes the warm tone over the brush drawing of Step 1. The drawing is dry to the touch but still soluble, and so the artist moves his brush very gently. Some of the original lines dissolve and blur, but many of the lines are still visible. He reinforces some of these lines, such as the contours of the handle.

Step 4. The tone of the bucket is tacky as soon as the solvent evaporates. Now the artist works with light, decisive touches, using a pointed soft-hair brush to draw dark lines over the tacky color. At the right, he draws with a damp brush to make ragged strokes that suggest the texture of the wood. The onions are covered with a mixture of cadmium yellow, a drop of burnt umber, and white. So far, the artist has diluted all his mixtures to a fluid consistency with Liquin and lots of solvent; he'll continue to do so throughout the demonstration.

Step 5. The artist continues to develop the detail of the wooden bucket with light, deft touches over the tacky color of Steps 2 and 3. The crisp, dark strokes are burnt umber, yellow ochre, and a speck of cadmium red. A damp brush is used again for the rough texture of the wood. Tiny touches of light on the edges of the shapes are slender strokes of yellow ochre, white, and a hint of burnt umber. The shadows are gradually darkened.

Step 6. The round shapes of the onions are built up with curving strokes that follow the contours of the forms. The artist uses a pointed brush to draw parallel, arclike strokes of cadmium yellow, yellow ochre, and white, with a hint of burnt umber in the shadows. The dark centers of the onions are small touches of burnt sienna and ultramarine blue with a drop of cadmium red. The underlying tone—first applied in Step 4—shines through.

Step 7. The artist takes a break for a couple of hours—it's lunchtime—and lets the painting grow thoroughly dry to the touch. When he goes back to work, the surface of the picture *feels* dry. Actually, it won't be *really* dry for another forty-eight hours—the color is still soluble if the artist scrubs hard enough—but it's dry enough to paint over with a light touch. And so now he finishes the detail of the bucket with the same dark mixture he's been using in Steps 3, 4, 5, and 6. He draws the cracks in the old wall with this same mixture, adding a touch of ultramarine blue for the shadow that he brushes over the left side of the floor on which the bucket stands. To suggest the irregular texture of the wall, he brushes some cool, pale strokes of ultramarine blue and white on the left-hand side above the bucket and then spatters dark droplets of the shadow mixture to the right and left. The shadows on the onion are reinforced with subtle strokes of ultramarine blue, burnt sienna, and yellow ochre. Hairy fibers are added to the onions with burnt umber and yellow ochre. The highlights on the onions are accentuated with white and a hint of yellow ochre. This mixture is also used to pick out the lighted edges of the wooden shapes in the bucket. The whole secret of this technique is to work with highly diluted color, allowing the solvent to evaporate between stages, so that you go back to work on tacky or touch-dry color. You must also learn to work with rapid, decisive strokes—and a delicate touch—so that the underlying color won't dissolve when you go over it. Of course, to play it safe, there's nothing wrong with taking an overnight break to be certain that you're working on much drier color the following morning.

Demonstration 6

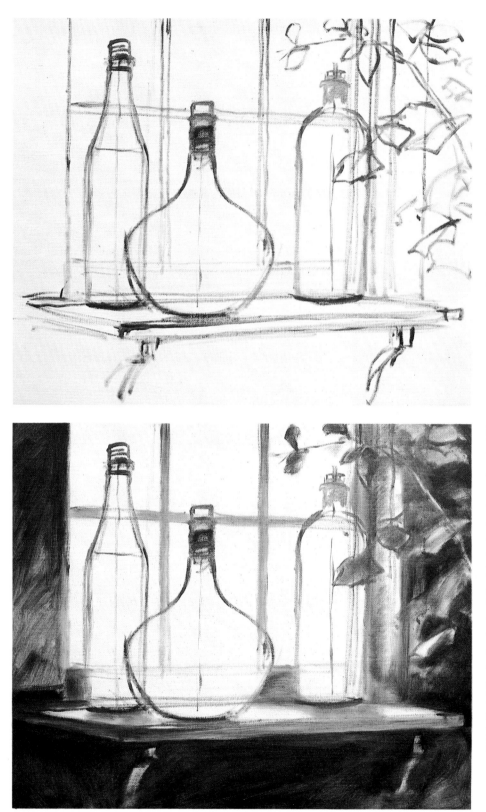

Step 1. In contrast with the direct painting techniques in Demonstrations 1 through 5, the old masters often divided their painting operations into distinct and separate phases called underpainting and overpainting. Demonstration 6 shows the simplest of these multiple-phase techniques. As usual, the artist starts with a brush drawing on the canvas. A round soft-hair brush draws the major shapes with a mixture that will harmonize with the colors of the finished picture: burnt sienna, ivory black, and plenty of solvent.

Step 2. Still working with burnt sienna and ivory black diluted with solvent to a fluid consistency, the artist begins to brush in the darks and the middletones that surround the sunlit window. For the paler tones, he adds a hint of white and more solvent. What's starting to emerge is a study of the subject painted entirely in a warm monochrome. Step 2 already displays a convincing sense of light and shadow, like a drawing in brown chalk. Steps 2 and 3 are painted with a long, springy bristle brush.

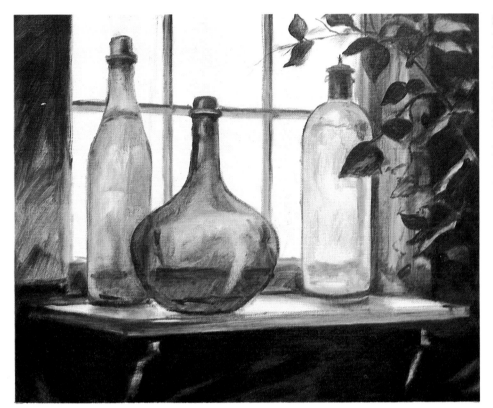

Step 3. Now the artist develops the forms of the bottles with the same warm mixture, brightening the central bottle with a bit more burnt sienna. He darkens the mullions between the windowpanes, the leaves, the shadows on the left wall, and the area beneath the shelf. The lighter tones contain more solvent and a bit of white. The highlights are wiped out of the wet color with a rag. We now see a complete study of the subject in monochrome—defining the forms, lights, and shadows. This *underpainting* is allowed to dry thoroughly for twenty-four hours.

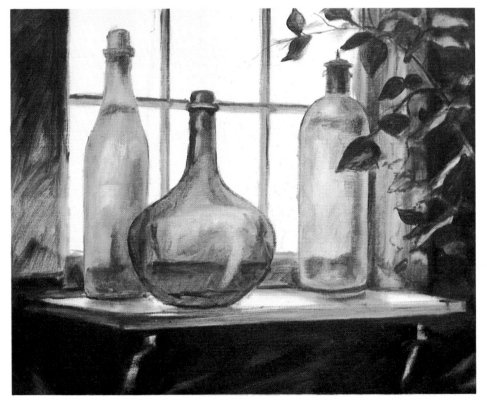

Step 4. Having solved all the problems of drawing, light and shade, and composition in the underpainting, the artist can now concentrate entirely on color. He mixes a transparent glaze of cadmium yellow, ultramarine blue, and viridian, diluted with Liquin and a drop of solvent, and brushes this over the bottle at the left. Then the bottle at the right is glazed with cadmium yellow and cadmium red, diluted with Liquin and some solvent; more cadmium red and some alizarin crimson are added for the darker tones. The glazes are applied with flat soft-hair brushes.

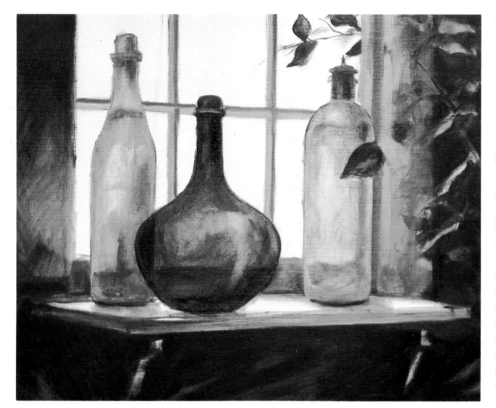

Step 5. The center bottle is glazed with ultramarine blue, viridian, and cadmium yellow diluted with Liquin, like the other glazes. The left wall is warmed with a glaze of burnt sienna, cadmium yellow, and yellow ochre. The right wall is cooled with a semitransparent scumble of viridian, yellow ochre, and white that partly obscures the leaves—which the artist wants to repaint. He also corrects the bottle at the right by scumbling cadmium yellow and white over the dark areas. He paints the mullions with an opaque mixture of viridian, burnt umber, and white.

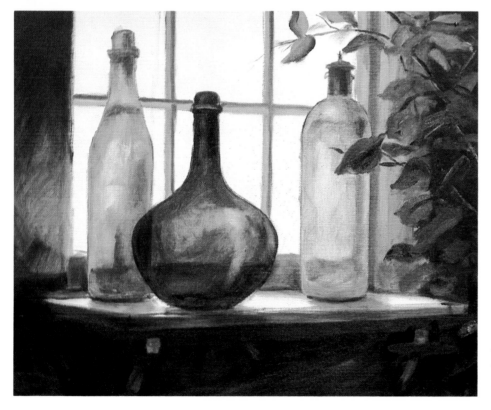

Step 6. The artist allows the painting to dry overnight so it feels quite dry. Then he repaints the leaves with phthalo blue, cadmium yellow, burnt umber, and white, adding more yellow for the lighted areas. He glazes the luminous shadows on the shelf—and the dark edge—with burnt sienna and cadmium yellow. The deep shadow beneath the shelf is glazed with a rich, dark tone produced by mixing phthalo blue, burnt sienna, and alizarin crimson. Slender strokes of this dark mixture are placed among the leaves to create the stems and the shadows.

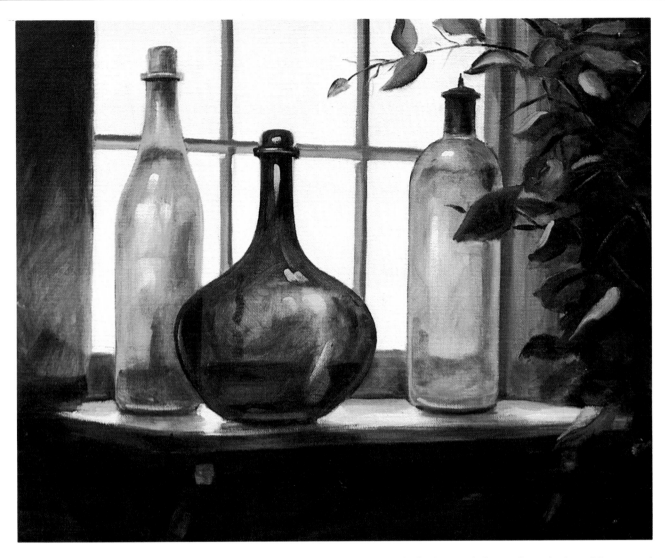

Step 7. With a sunny, opaque mixture of cadmium yellow and white, diluted with Liquin to a creamy consistency, the artist places highlights on the bottles and the reflection of the glowing sunlight on the surface of the shelf. He reinforces the darks on the bottles with phthalo blue, burnt sienna, and a touch of yellow ochre. Then he throws a deep shadow over and behind the leaves by glazing the right-hand part of the picture with this same mixture. Against this murky background, he spotlights a few leaves with opaque touches of phthalo blue, cadmium yellow, burnt sienna, and white. The bottle at the right is brightened by a final glaze of burnt sienna, cadmium red, and cadmium yellow. Now compare the finished painting with the monochrome underpainting in Step 3. Observe how the contours, lights, and shadows of the underpainting shine through the transparent glazes and the semi-transparent scumbles, which are like layers of stained glass. This picture is underpainted in fairly transparent, warm tones. But you should also experiment with monochrome underpaintings that are more opaque: add white to the warm underpainting mixtures; and try underpainting in shades of gray, produced by mixing ultramarine blue with burnt umber or burnt sienna and white. Be sure to let the underpainting dry thoroughly before you start the overpainting. The overpainting in this demonstration was executed with soft-hair brushes, both round and flat, but you should also try overpainting with bristle brushes, which produce rougher strokes.

Demonstration 7

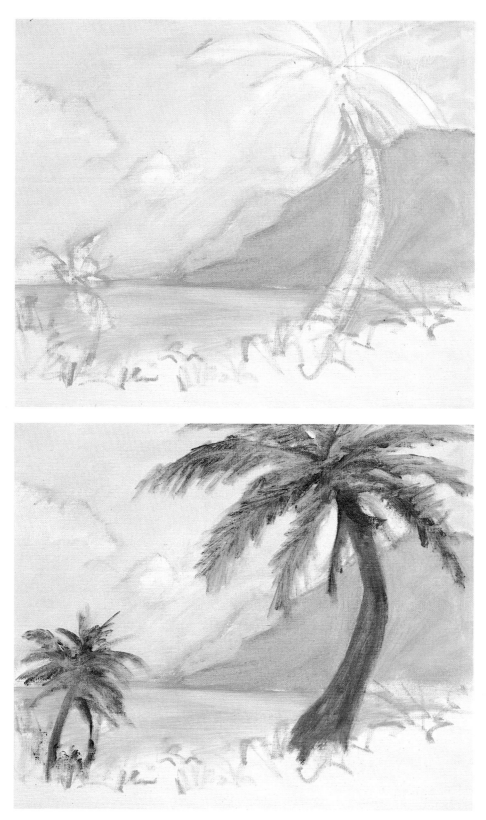

Step 1. Now the artist demonstrates underpainting in color—which will shine through the glazes and scumbles of the overpainting to create optical mixtures. (The underpainting and overpainting will "mix" in the viewer's eye.) The artist begins with a brush drawing in alizarin crimson with a speck of phthalo blue and plenty of white. He brushes cadmium red and white over the sky; alizarin crimson, ultramarine blue, and white over the mountains; cadmium red, cadmium yellow, a drop of ultramarine blue, and white over the sea. At this stage, colors are diluted only with solvent.

Step 2. The tops of the palm trees are underpainted in cadmium yellow and ultramarine blue with a round bristle brush whose strokes follow the shapes of the tropical foliage. The darks contain more blue. The tree trunks are underpainted with alizarin crimson, burnt sienna, and ultramarine blue—with a bit more blue in the shadow areas directly beneath the foliage. The artist still works with bristle brushes and dilutes his color with solvent alone so that the color is quite thin and fluid.

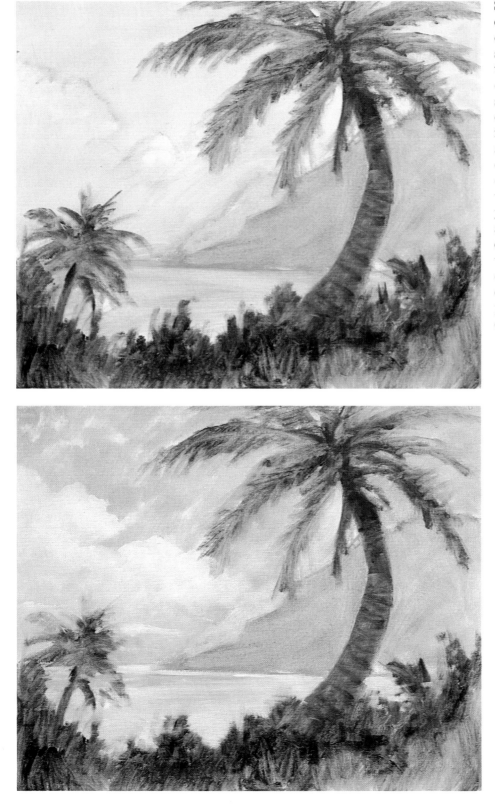

Step 3. Small and medium-sized bristle brushes cover the foreground with scrubby, irregular strokes that suggest the profusion of tropical growth. These strokes are mixtures of cadmium yellow and viridian in the warm, pale areas; cadmium yellow, cadmium red, and a drop of ultramarine blue in the warm darks; and cadmium yellow, ultramarine blue, and viridian in the cool darks. The artist is still working only with tube color and solvent. The underpainting is now complete—and is allowed to dry for eighteen hours.

Step 4. The underpainting looks and feels dry enough to paint over. The artist scumbles phthalo blue, viridian, yellow ochre, and white over the sky, letting the warm undertone shine through. He scumbles phthalo blue, alizarin crimson, and white over the shadowy parts of the clouds; and white tinted with yellow ochre and alizarin crimson over the sunlit tops. The cool tones of the sea are scumbled with phthalo blue, yellow ochre, and white, while the warm tones are cadmium red, yellow ochre, and white. Colors are diluted with Liquin and solvent.

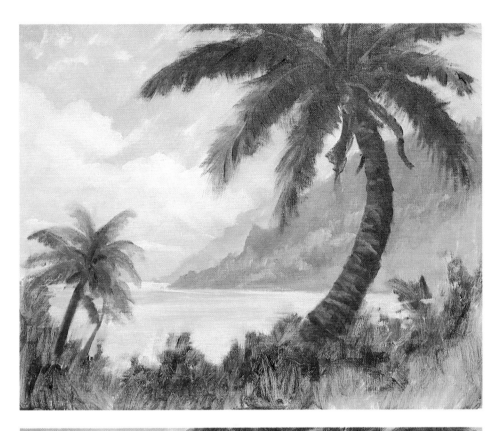

Step 5. The mountains are scumbled with phthalo blue, alizarin crimson, and varying amounts of white. The wooded slope beneath the mountains is scumbled with varied mixtures of cadmium yellow, burnt sienna, phthalo blue, and white. Then the artist glazes the tops of the two trees with viridian and burnt sienna, letting the underpainting shine through to suggest sunlight on the leaves. He glazes the dark bands of the trunks with burnt sienna, alizarin crimson, and ultramarine blue—adding white or cadmium red to the mixture for the brighter bands. He's using long, springy bristle brushes.

Step 6. Over the sunny underpainting of the foreground, the artist glazes warm strokes of cadmium red and yellow, intermingled with cooler, darker strokes of viridian and alizarin crimson. Applied with small, resilient bristle brushes, the strokes sometimes mingle and sometimes leave gaps for the underpainting to come through. Here, as in the foliage of the palms, the interaction of the underpainting and the overpainting creates a feeling of luminous shadow interrupted by patches of sunlight. The fluid glaze mixtures are again diluted with Liquin and solvent.

Step 7. Diluting his final mixtures with Liquin alone, the artist now strengthens the darks in the palm trees and in the foreground with small strokes made with the tip of a round soft-hair brush. Surprisingly, these darks contain no ivory black but are a mixture of phthalo blue (one of the most brilliant colors on the palette), burnt umber, and alizarin crimson, yielding a particularly rich, warm "black." With the point of the brush, the artist moves over the entire foreground, deepening the shadows and adding touches of detail. He also adds small, opaque touches of light—suggesting blades of grass and leaves in sunlight—with yellow ochre, phthalo blue, and white. The sharp point of the wooden brush handle scratches details out of the wet paint in the palm foliage, revealing the pale underpainting beneath the dark glaze. To enliven the foreground grass and weeds, he adds a last few strokes of cadmium red and yellow, blended to produce the hot tone of tropical flowers. Studying the finished painting, you can see how the underpainting influences the overpainting to create optical mixtures. The cool tones of the sky, clouds, and sea are all warmed by the underpainting to suggest the unique light of a tropical climate. In the same way, the underpainting and overpainting of the weedy foreground blend to create an intricate pattern of sunlight and cool shadow. The painting also demonstrates an important lesson about how to use glazes and scumbles. Glazes are particularly effective for painting shadows, while scumbles are more effective for painting lighted areas. Glazes also tend to move forward in the picture, while scumbles (and opaque color) are especially good for creating a sense of distance. Thus, the artist has placed his glazes in the shadowy foreground and placed his scumbles in the middleground and the distant parts of the landscape.

Demonstration 8

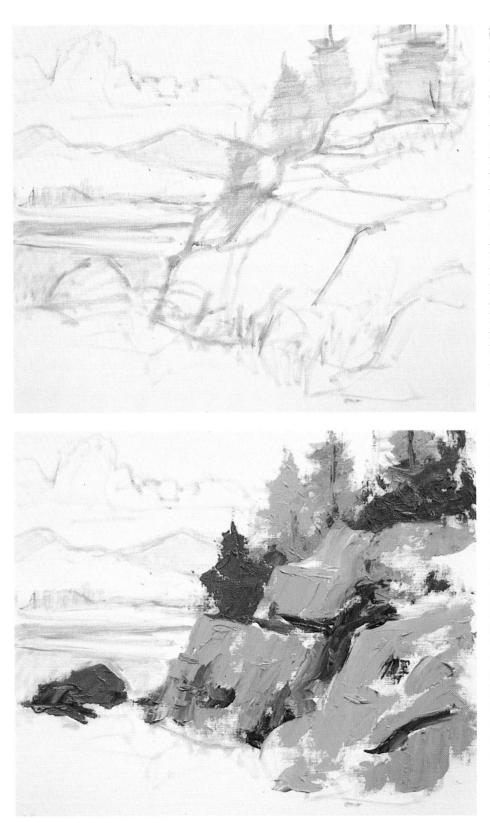

Step 1. Still another kind of underpainting creates textures—as well as colors—that will have a decisive influence on the overpainting. A textured underpainting is most effective for a subject that's full of natural texture and detail, such as this study of rough rocks surrounded by weeds and evergreens. The artist begins the canvas, as always, with a brush drawing in delicate, atmospheric tones that will soon disappear under thick layers of paint. The drawing is done in ultramarine blue, alizarin crimson, and white, plus plenty of solvent.

Step 2. The artist blends burnt umber, ultramarine blue, yellow ochre, and white with Oleopasto to produce a thick paste that he spreads over the rocks with broad knife strokes. The shadows within the rocks—and the dark rocks at the left—contain more umber and blue. The pale trees are thick knife strokes of viridian, burnt umber, yellow ochre, and white, blended with Oleopasto. For the darker trees, the artist adds more umber. The artist consciously plans his strokes to look rough and erratic.

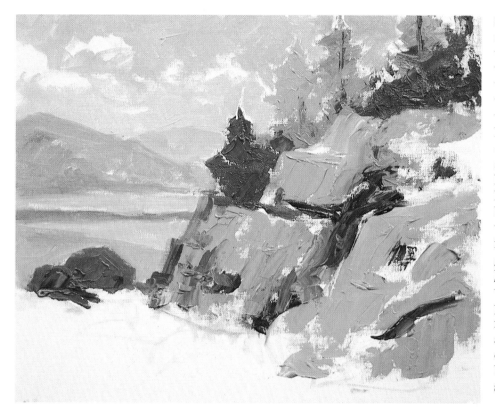

Step 3. The artist blends a subdued, neutral tone—ultramarine blue, burnt umber, yellow ochre, white, and Oleopasto—for the sky, which he paints with a big bristle brush, leaving bare canvas for clouds. He adds more blue and less white for the hills. The cool strip of flat land is viridian, burnt umber, yellow ochre, and white—with more white in the lighter area. The golden tone on the flat land is yellow ochre and white, while the shadowy patch (above the dark rock) is the same mixture as the big rocks. These colors contain Oleopasto blended with a drop of solvent.

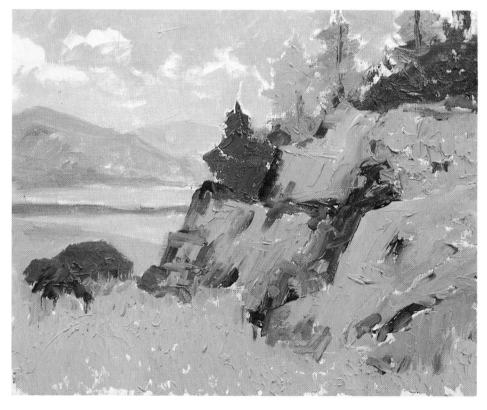

Step 4. The weedy foreground is painted with rough brush strokes: a mixture of ultramarine blue, cadmium yellow, burnt umber, white, and Oleopasto. Brush strokes of this same mixture are placed high on the rocks in the upper right. Where the meadow meets the bases of the big rocks, the artist adds a few strokes of the shadow mixture from Step 2: burnt umber, ultramarine blue, yellow ochre, and white. The textured underpainting is finished and allowed to dry. Since the color is thick, it's best to wait forty-eight hours before the artist overpaints.

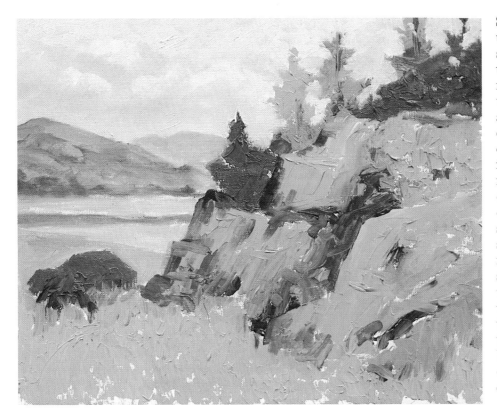

Step 5. Over the subdued underpainting—which shows through in places— the artist scumbles a sky mixture of phthalo blue, viridian, burnt umber, and white. For the shadowy undersides of the clouds, he substitutes alizarin crimson in this mixture. The sunny tops of the clouds are scumbles of white, tinted with the shadow tone. The hills are scumbled with ultramarine blue, alizarin crimson, burnt sienna, and white—and more blue in the shadows. A row of trees is placed beneath the hills with viridian, burnt umber, yellow ochre, and white. The medium is Liquin.

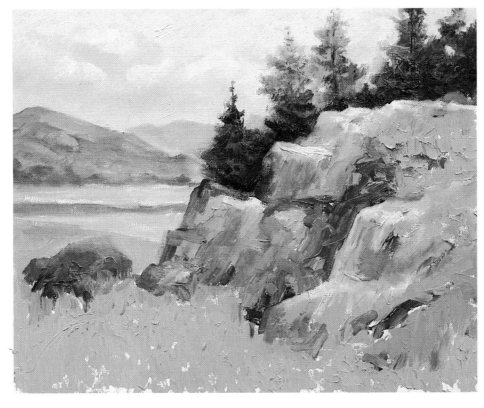

Step 6. The artist builds up the shadowy tones of the trees with a glaze of phthalo blue, burnt sienna, and yellow ochre, diluted with Liquin—like all the glazes and scumbles in the overpainting. He leaves gaps and thin spots to show the underpainting. He gradually begins to develop the shadow tones on the rocks with glazes of burnt umber and ultramarine blue. And he starts to develop the lighted top planes of the rocks with scumbles of yellow ochre and white. In the trees and the rocks, the rough underpainting breaks up the overpainting strokes, which look ragged and broken.

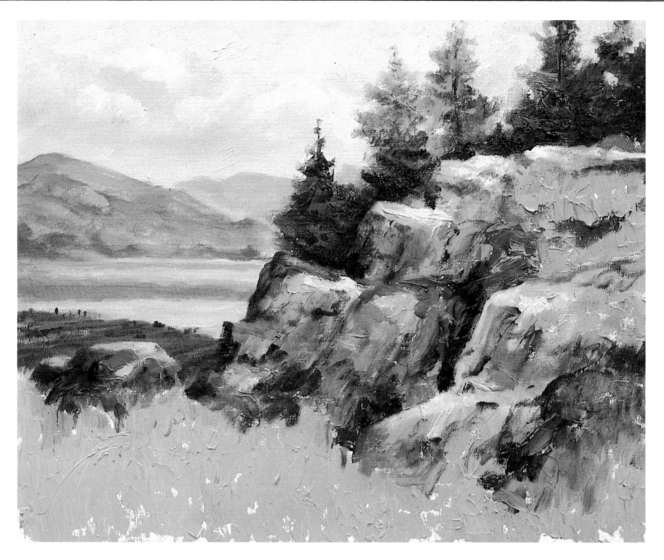

Step 7. Going back over the shadowy sides of the rocks with stroke after stroke, the artist gradually darkens the shadows with heavier glazes of burnt umber and ultramarine blue. At the same time, he gradually brightens the lighted tops of the rocks with scumbles of yellow ochre and white. As the glazes and scumbles thicken, the influence of the rough underpainting becomes more pronounced. The overpainting actually seems to bring out the shapes of the underlying knife strokes—making the rocks look rougher and more three-dimensional. The artist glazes a cool shadow over the flat land behind the dark rock at the left. This is a blend of ultramarine blue, cadmium yellow, and burnt umber, with strips of underpainting shining through, as usual. By contrast, this shadow brightens the patch of sunlight on the flat meadow beyond.

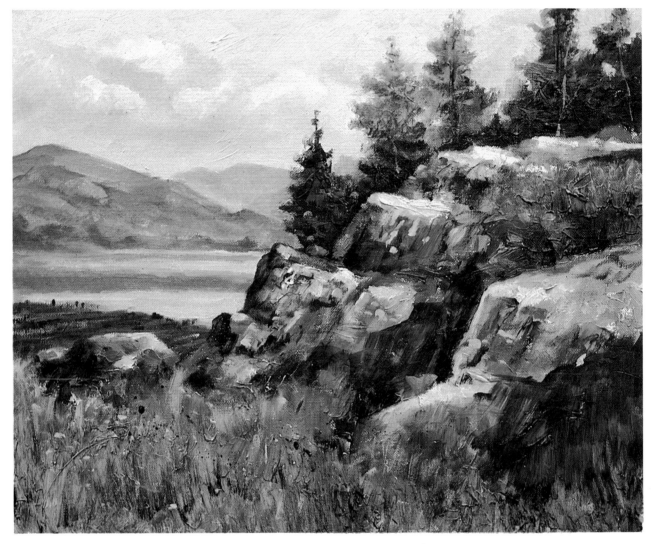

Step 8. Finally, the artist glazes the foreground grasses with cadmium yellow, ultramarine blue, and touches of burnt sienna here and there. This same glaze is carried over the clump of weeds that grows among the rocks in the upper right. For the shadowy tones among the grasses, the artist adds more blue and burnt sienna. The grass strokes vary in lightness and darkness to suggest the intricate play of sunlight and shadow. The artist continues to darken the shadows on the rocks; now there are distinct planes of darkness in the areas that face away from the sun. He also brightens the sunlit areas with touches of thick, opaque color—yellow ochre, burnt sienna, and white. The last details are the tree trunks among the dark evergreens (burnt umber, yellow ochre, and white) and the scattered wild flowers in the foreground (cadmium yellow and white). The strategy of the painting is worth remembering. The underpainting colors are subdued because it's the *texture* of the underpainting, not the color, that matters most. Most of the underpainting colors harmonize (rather than contrast) with the overpainting. The underpainting textures are kept in the foreground, where they contrast with the smoother textures of the distant landscape. The textures would have less impact if they covered the whole canvas. He underpaints the rocks with knife strokes to accentuate the blocky character of the rocks, but underpaints the foreground grasses with a brush because the bristles make grooves in the paint—and the glazes sink into these grooves to suggest blades of grass and clumps of weeds. The secret is careful planning of knife and brush strokes. And it's important to switch from Oleopasto in the underpainting to Liquin in the overpainting so that the glazes and scumbles will sink into the textured strokes. A note of caution about rough paint textures: your strokes don't have to be tremendously thick to do the job—but if you do plan to pile up the paint as thickly as Van Gogh did, a panel will carry the weight more easily than canvas and will minimize the danger of cracking. And be sure to wait a few months before you varnish an unusually thick paint layer.

Varied Techniques. The preceding demonstrations merely serve to introduce the basic alkyd painting techniques—but there are many others that you'll discover as you work with the medium. Here are some special effects and technical tricks that are worth trying.

Drybrush. This is a technique that will be familiar if you've worked with watercolor or acrylic. There are two ways to begin. You can load your brush with fluid color and wipe the hairs on a newspaper or paper towel so that only a small quantity of color remains on the brush. Or you can pick up a small quantity of thick color, scrubbing it around on the palette to make sure that not too much color sticks to the bristles. Then you skim the brush lightly over the canvas (or any textured painting surface) so that you hit the high points of the weave and skip across the valleys, leaving a ragged stroke that's good for subjects like tree bark and rocks.

Wiping Out. While alkyd color is still wet on the painting surface, you can wipe away parts of the paint layer with a rag to expose the underlying canvas to suggest a cloud, foam on a wave, or light on a cheek. If you've underpainted in some other color and allowed the paint to dry overnight, you can overpaint the next day and then wipe away areas of the overpainting to reveal what's underneath. If the color is tacky or touch dry, just moisten the cloth with solvent.

Spattering. To suggest debris on a beach, lichen on a stone wall, or pebbles on a road, try spattering. Load a long, springy brush with very liquid color. Hold one hand over the painting surface. Then whack the brush handle against that hand, aiming the brush so that droplets of liquid paint fly onto the painting surface.

Imprinting. Brushes aren't the only tools for applying paint. Try dipping crumpled paper, a wad of coarse fabric, or a scrap of wrinkled metal foil into the color on your palette—and press this improvised painting tool against the picture to suggest textures like weathered stone or wood.

Scratching. The pointed end of your brush handle or the sharp tip of your palette knife can scratch away slender lines—right down to the bare canvas if you wish—to indicate details like sunlit blades of grass in a meadow or wisps of light hair in a portrait.

Knife Painting. If you like to work with thick, juicy color, the painting knife (not the palette knife) may be your favorite tool. The tapered, flexible knife blade is more versatile than you might expect. The tip will execute small details, while you can paint big areas with the side of the blade. The right paint consistency is essential, so blend your tube color with Oleopasto to create a consistency that's soft enough to spread easily but dense enough to give you the bold textures that you want. Knife painting is especially suited to subjects with dramatic shapes and lighting effects, like masses of trees in bright sunlight, or a stormy seascape. Plan each stroke carefully, place the stroke on the canvas with a decisive movement, and stop! Don't keep pushing the color around until it turns to a shapeless mass of mush. Let those knife strokes show.

Corrections Within Forty-Eight Hours. On the first or second working day, while the color is still wet, tacky, or just dry to the touch, corrections are easy. Scrape off the wet color with a palette knife. Or use a solvent-moistened rag to dissolve tacky or touch-dry color. You can then repaint immediately.

Corrections After Forty-Eight Hours. Allowed to dry forty-eight hours, a layer of alkyd color no longer yields to scraping or mild solvents. The paint film is just too tough. You *can* buy more powerful solvents—but now it's easy to paint right over the dried color without taking the trouble to remove it. Rubbing a touch of liquid medium into the surface of the dry canvas—a method called "oiling out"—will make the surface *feel* like wet paint when you touch it with the brush. Your brushwork will be more fluent on the moist surface and your corrections will look better integrated with the rest of the picture. (Oiling out tends to produce a slick surface, so save this technique for your final paint layer.) You can just cover a mistake with opaque color, of course. But you can also darken an area or alter the color with a transparent glaze that lets the underlying color shine through. Or you can lighten an area with a semitransparent mist of color, or scumble.

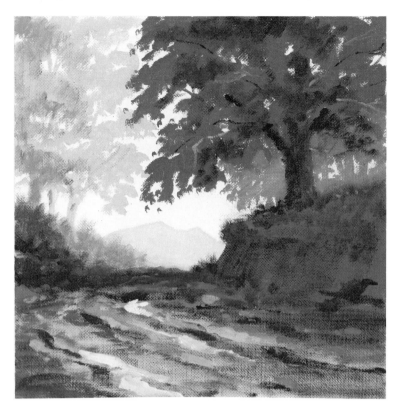

Drybrush. Commonly used in watercolor and acrylic painting, the technique called drybrush works just as well in alkyd. The brush carries a small amount of color—just enough to coat the bristles—and is skimmed lightly over the painting surface. Canvas, rough paper, or textured gesso is best for drybrush because the high points of the painting surface protrude to catch the moving brush. Thus, the brush deposits moist color on the "peaks" of the painting surface and skips over the "valleys." The foreground of this landscape is covered with drybrush strokes.

Drybrush (detail). Studying the foreground more closely, you can see how the high points of the canvas catch the color from the skimming brush, while the low points are left untouched. To make light drybrush strokes, the artist presses lightly on the brush. To make darker strokes, he presses harder to force the color down into the weave.

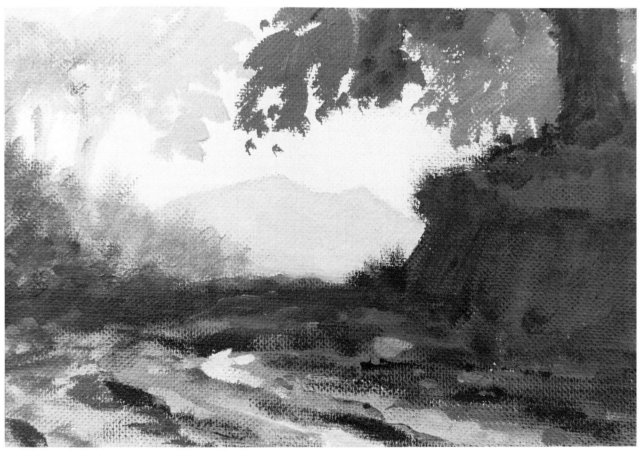

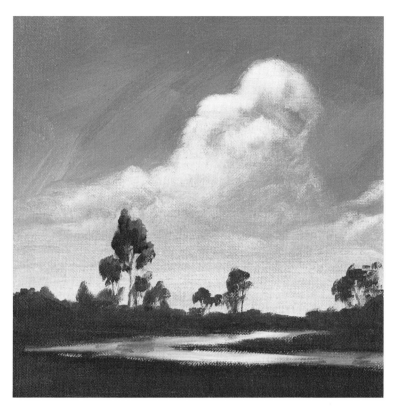

Wiping Out. There are times when the best way to render a subject is to *remove* paint rather than add it to the painting surface. This cloud and the pale lower sky are both wiped out of a layer of wet alkyd.

Wiping Out (detail). This close-up shows that the artist has wiped out very selectively. For the lighted top of the cloud, he's wiped away a great deal of color, practically down to the white canvas. In the shadow area of the cloud, he's removed just a bit of color. To create the glow of light in the lower sky, he's wiped away somewhat more color, but he's left just a trace. Obviously, the artist begins by covering the whole sky area with solid color and then attacks the sky with a clean, hard-surfaced cloth while the color is still wet. (If the color grows tacky, he can remove it by moistening the cloth with solvent.)

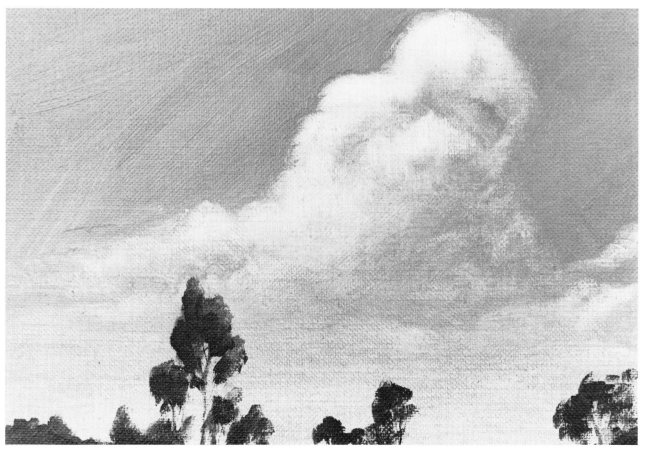

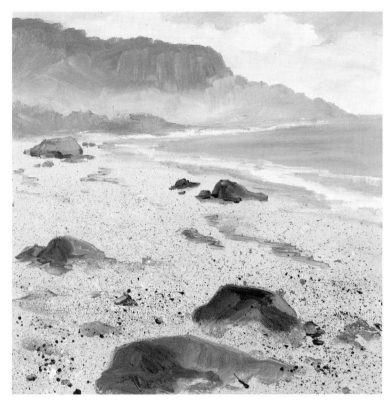

Spattering. Here's another technique that's widely used in watercolor and acrylic but is also worth trying in alkyd. To render the pebbles on a beach—or textural detail on weathered wood or stone—try spattering. You dip a long, resilient brush into very wet color and whack the brush handle over your other hand so that the liquid color sprays in droplets over the painting surface. That's how this beach is done.

Spattering (detail). This enlarged close-up shows that the artist has first brushed a sandy tone over the whole beach, allowed the undertone to become dry to the touch, and then spattered the beach with darker color. With the tip of a small, pointed soft-hair brush, he enlarges some of the bigger spatters to create pebbles here and there on the sand. And notice that he completes the job by spattering lighter droplets among the dark spots.

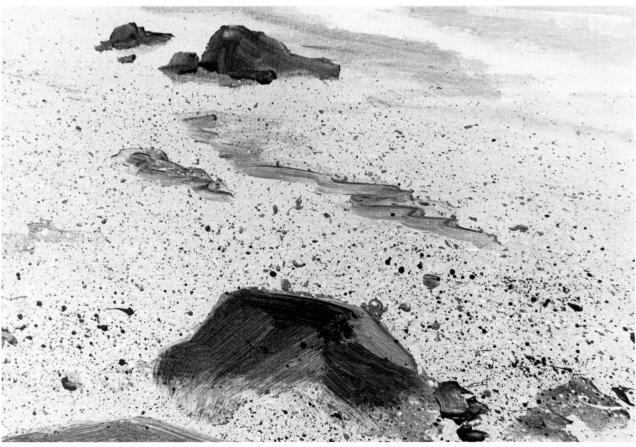

Imprinting. For some subjects, an improvised tool will do a better job than a brush. The texture of the boulders in this old stone wall is created by crumpling a stiff cloth, dipping the cloth into moist color, and pressing the crumpled wad against the canvas. The imprint of the cloth suggests the stony texture.

Imprinting (detail). When you examine the boulders in this close-up, you see that the mottled texture of the imprint has been modified by additional painting operations. The cloth wipes away some of the lights from the wet color. Drybrush strokes add more texture to the undersides of the bounders. And strokes of dark color emphasize the edges of the various forms.

Scratching. The pointed end of the wooden brush handle is a valuable tool for scratching pale lines into wet color. If you press hard enough, you can *almost* get down to the bare white painting surface. Less pressure leaves more paint on the surface and produces a less distinct line. The light-struck weeds in this landscape are scratched into the wet alkyd color with the end of the brush handle. So are the pale twigs farther up on the trunk. The tip of a stiff palette knife is also a good scratching tool.

Scratching (detail). In this close-up of the weedy foreground, you can see that the scratching tool doesn't remove a clean, wiry white line, but a ragged line. Just as the texture of the canvas breaks up and softens the brush stroke, the weave also softens the effects of the scratching tool—which tends to hit the high points of the weave and skip over the low points. Thus, the scratches don't leap out of the painting.

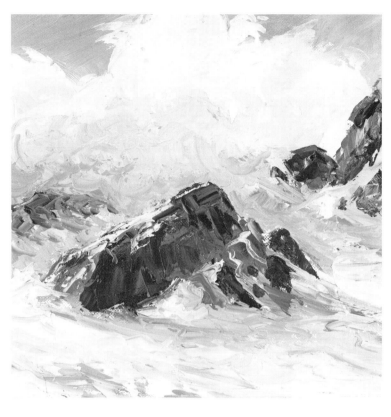

Knife Painting. For bright color and bold textures, no painting tool compares with the painting knife. The strokes of the knife are both thick and smooth—a combination that makes colors look stronger. And the spontaneity of the knife stroke lends tremendous vitality to a dramatic subject such as this rock surrounded by crashing foam and moving water.

Knife Painting (detail). The versatility of the knife blade is evident in this close-up of the rock and the turbulent foam. The side of the knife paints the broad strokes that represent the dark side of the rock. Then the tip of the blade—as springy as a brush—paints the paler, thinner strokes that represent the foam trickling down the rock and surging around it.

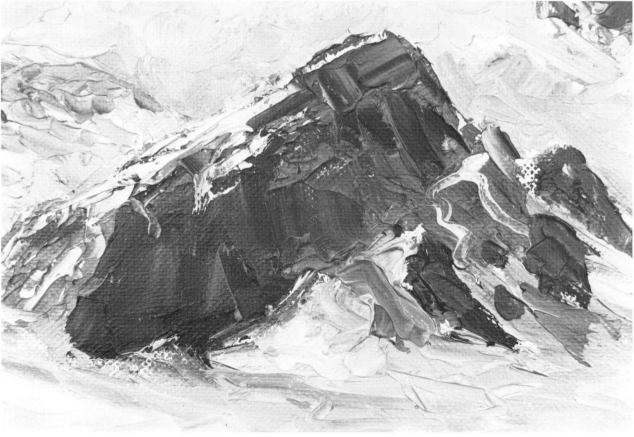

Step 1. A wet alkyd painting—or one that's dry to the touch—is easy to correct. In this first stage, the trees are badly placed and the shapes are lumpy and lifeless. The dark tree at the left is too close to the edge of the canvas. The tree at the right is badly drawn. And both are too big. They need to be wiped out and repainted.

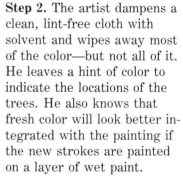

Step 2. The artist dampens a clean, lint-free cloth with solvent and wipes away most of the color—but not all of it. He leaves a hint of color to indicate the locations of the trees. He also knows that fresh color will look better integrated with the painting if the new strokes are painted on a layer of wet paint.

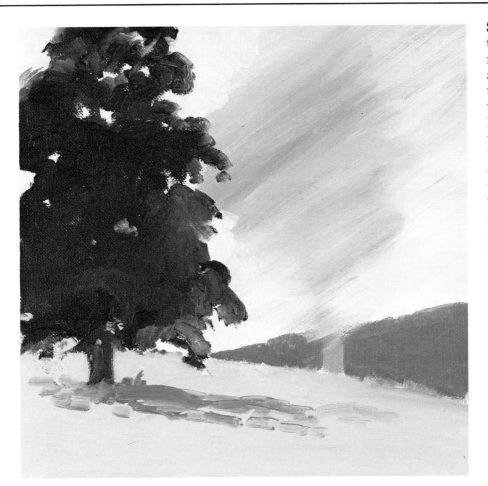

Step 3. Working back into the thin layer of damp color that remains on the canvas, the artist begins by repainting the dark tree at the left. Now the tree is farther away and has a more convincing, realistic shape. The fresh strokes blend with the underlying color and therefore melt into the damp painting surface. The correction doesn't look as if it's superimposed on the painting, but merges with the original paint layer.

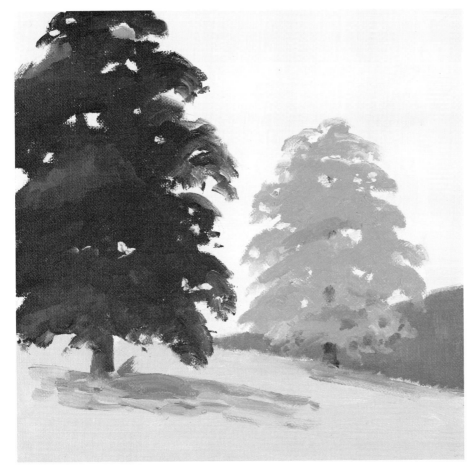

Step 4. The paler, more distant tree is also painted over the damp surface so that the new strokes merge with what's left of the old. The artist lightens and brightens the sky, working carefully around the revised tree shapes. In the corrected painting, notice that the strokes have soft, slightly blurred edges, produced by working over damp color. This softness is the key to a successful correction.

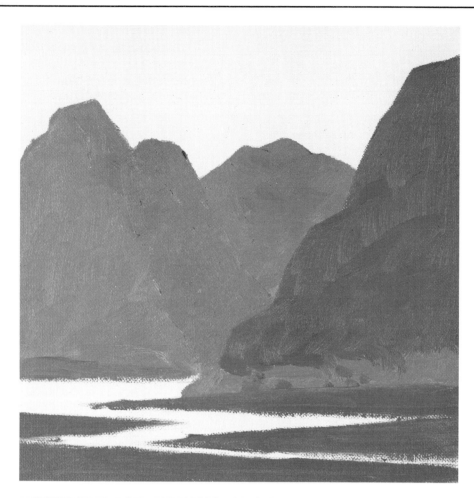

Step 1. This landscape—with its obvious faults—is dry and can no longer be wiped away and repainted on damp color. But corrections are still easy to make. The problem here is that all the mountains are so close in value that there's no sense of foreground, middleground, and background. Major corrections must be made on the dry painting.

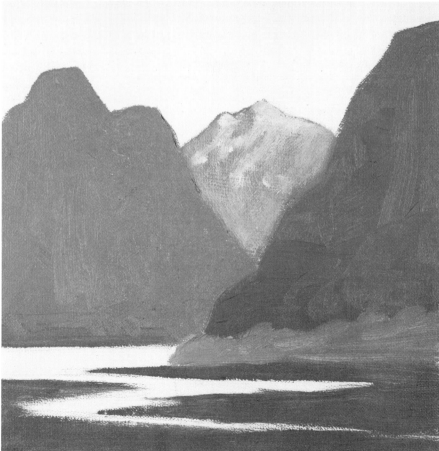

Step 2. To create the effect of working on a *wet* painting, the artist rubs a very thin layer of Liquin painting medium into the canvas. (This operation, called oiling out, can be done with a brush or a cloth.) Then he scumbles a pale, semitransparent mist of color over the distant mountain, which immediately drops away into the distance. The underlying layer of painting medium softens the strokes, creating the impression that the fresh color melts into the dry color beneath.

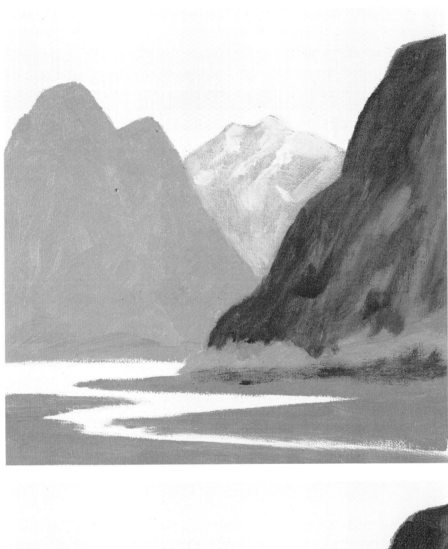

Step 3. First oiling out the dark mountain at the right with a thin layer of painting medium, the artist then glazes a dark, transparent tone over the rocky shape. The glaze permits some of the underlying color to shine through. The old and new paint layers seem to mix. And the mountain moves into the foreground.

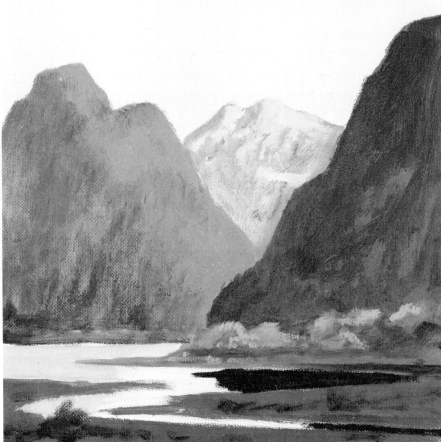

Step 4. Finally oiling out the mountain at the left, the artist adds a delicate glaze to indicate the shadow side of the shape. He develops and refines the tones that he first applied in Steps 2 and 3. Reflections are added to the water. Further details are added to the flat landscape at the foot of mountains. The entire painting has been transformed by adding glazes and scumbles.

Care of Brushes and Knives. At the end of the day, rinse your brushes in solvent for the last time; wipe them on newspaper (or any absorbent scrap paper) to dry them; lather them in mild soap and warm water (no harsh laundry soaps or *hot* water) again and again until the lather comes out pure white; rinse them in clear water; and let them dry in the open air. Use a rag, moistened with a little solvent, to wipe your brush handles, knife blades, and knife handles clean and smooth. You can dry your brushes and store them at the same time in a wide-mouthed jar—with the hair ends up, of course. Store knives flat in a drawer or in your paint box.

Studio Cleanup. If you're working on a wooden palette, scrape it clean with your palette knife at the end of the painting day, and then wipe the surface clean with a rag and solvent. (If you wait a couple of days or let the color pile up on the palette for weeks at a time, as some oil painters do, the palette will soon be unusable, since alkyd is so hard to remove once it's dry.) If you're working on a paper tear-off palette, get rid of the soiled top sheet so you can start on a clean sheet the next day. It's a good idea to wipe the necks of tubes and bottles with a rag or paper towel—and a bit of solvent—so they'll be easy to open the following day. And wipe the labels so you can read them! Screw on the tops of tubes and bottles tightly so that the color won't dry up and solvents won't evaporate. Discard all soiled rags and scrap paper immediately. Never store them; they're a fire hazard. Air out your studio, preferably with the aid of a fan that will send all those paint smells out the window. Hang up your paint-stained clothes to dry—someplace where they won't touch and soil your *good* clothes. If you get alkyd on a favorite suit or dress, dry cleaning may not work. Alkyd is tough to remove.

Personal Cleanup. Lather your hands with soap and warm water to remove all traces of color, mediums, and solvents. A stiff laundry brush will help—especially under your fingernails. Some artists wash their hands with turpentine or petroleum solvent, but it's a bad habit. Prolonged exposure to that much solvent can damage your skin. Soap and water will do just as good a job.

Safety Precautions. Painting with alkyd requires all the normal safety precautions that a well-informed artist takes when working with oil paints. The alkyd resin in alkyd colors and mediums isn't hazardous. Among the tube colors, only the lead colors—flake white and Naples yellow—and possibly the cadmiums can be toxic, but these time-honored colors are safe when used with normal care. Turpentine and various petroleum solvents—mineral spirits, white spirit, rectified petroleum, etc.—are the mildest solvents available to the artist. But it's important to understand that *all* solvents must be used with care. No matter what medium you work in, there are certain rules that you should follow in your studio. These rules apply equally to alkyd and to all other colors, mediums, and solvents.

(1) Don't ingest paint, medium, or solvent. This means that you should never eat or smoke in the studio, since there's always the chance that a stray bit of paint may get on your sandwich or your cigarette. And never hold a brush in your mouth.

(2) Don't get paint, medium, or solvent into your eyes.

(3) Avoid prolonged skin contact with paint, medium, or solvent. If you get a dab of color on your hand, wipe it off. And be sure to wash your skin thoroughly at the end of the painting session.

(4) Work in a well-ventilated room so that you don't have to breathe solvent vapors over a long period. Keep your windows open whenever you can. Better still, buy an exhaust fan to expel fumes outdoors. An inexpensive, portable fan, placed in front of an open window, is an excellent investment.

(5) Keep powerful industrial solvents out of the studio. They can produce toxic fumes and they're rough on your skin. Also avoid highly flammable solvents such as gasoline and kerosene (called petrol and paraffin in Britain).

(6) If you spray alkyd, dilute it with mineral spirits (white spirit in Britain). And when you spray *any* artists' color, work in a ventilated spray booth and wear a respirator.

Fat-over-Lean. The preservation of a painting begins not after the picture is done, but while the picture is being painted. The right technique is the key to permanence. An alkyd painting, like any painting, responds to the push and pull of temperature and humidity in the atmosphere. So the old "fat-over-lean" rule applies to alkyd painting, just as it does to oil painting. In any technique that involves more than one layer of paint, the earlier "lean" layers should always contain less painting medium and the later "fat" layers should contain more. Thus, the top layers are more flexible and more resistant to wear and tear.

Varnishing an Alkyd Painting. Since alkyd dries so quickly, you can apply a thin coat of retouching varnish at the end of twenty-four hours. The retouching varnish is just temporary protection, of course. After a month, a painting of normal thickness is ready for a final coat of a thicker picture varnish, as it's called. As in oil painting, the best varnish is a soft resin such as damar, mastic, or one of the synthetics—any one of which will dissolve easily in a mild solvent such as turpentine or one of the petroleum products mentioned earlier. These resins are all "soft" in the sense that they come off easily. When the picture is cleaned with a mild solvent, the soiled coat of protective varnish will come off, but the more resistant coat of alkyd underneath won't dissolve—and your picture will remain intact.

Varnishing Technique. If you use varnish that comes in an aerosol spray can, you'll find the manufacturer's instructions on the label. What's most important is spraying the varnish onto the picture gradually, moving the can from side to side with steady movements so that you make parallel, overlapping bands of varnish on the picture surface. Don't spray so much varnish on one spot that you create a shiny pool. Coat the picture evenly. (And keep that exhaust fan going.) Of course, many painters prefer the "handmade" look of a varnish coat that's applied with a brush. Use a soft nylon housepainter's brush and work with parallel strokes, moving the brush from top to bottom or from left to right—never crisscross your strokes. Avoid scrubbing back and forth so you won't disturb the smooth surface of the varnish coat.

Be sure to work on a horizontal, dust-free surface. Leave the picture there until it's absolutely dry.

Frames. The style of a frame is a personal matter. It's up to you to decide whether you like designs that are plain or ornate, historic or contemporary, colorful or subdued. But remember that the primary purpose of the frame is to protect the picture. If you choose a wooden frame, be sure it's thick and sturdy enough to protect the edges of the painting, rigid enough to prevent the canvas or panel from warping, and strong enough to carry the weight of the painting when it's hung on a wall. If you like the contemporary fashion of framing a canvas in thin, almost invisible strips—instead of the thicker traditional moldings—you'll find that metal strips provide better protection and greater strength. A picture on stretched canvas needs the additional protection of a sheet of heavy cardboard or thin hardboard stapled or nailed to the back of the frame or the backs of the stretcher bars. When the painting is on a panel or on canvas, there's no need for a protective sheet of glass. A good coat of varnish is enough.

Framing Paintings on Paper. An alkyd painting that's executed on paper should be framed under glass and treated like a watercolor or any other work of art on paper. First, the picture should be placed in a mat (called a mount in Britain) that's made of acid-free paper, sometimes called "museum board." That is, the picture is sandwiched between two protective boards, one in front and one behind. The front board contains a window through which you see the picture. (Tape the painting into the mat with the glue-coated white cloth used by librarians to repair books—not with masking tape or cellophane tape, which will stain the painting.) The matted picture is then placed in a frame with a sheet of protective glass or clear plastic in front. There's no need for varnish; the glass does the same job. If you go to a professional picture framer to mat and frame a painting on paper, make absolutely sure that he or she works with acid-free mat board and avoids "sticky" tape. Framed properly, your painting can last a lifetime and can become a family heirloom!

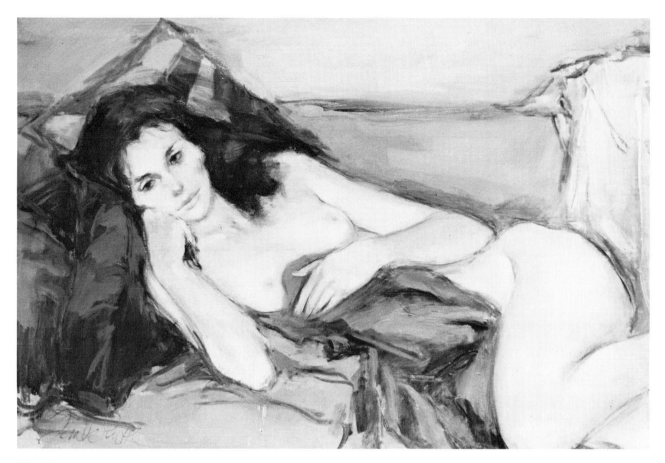

The Pause by Jan De Ruth, alkyd on canvas, 20″ × 30″ (51 ×76 cm), collection the artist, courtesy Gallery 306. Alkyd color responds to every spontaneous impulse of the brush. The pillows at the left are painted with broad, splashy strokes of fluid color—and every stroke is evident. The figure, in contrast with the pillows, is executed with inconspicuous strokes that are carefully fused by a soft brush. But then a slim, sharply pointed brush moves around the contours of the figure to accentuate a few edges. For the drapery beneath the model's hand—at the center of the painting—the artist uses thicker, rougher strokes than those on the pillows at the left. And the smooth, delicate tone of the drapery in the upper right is quickly painted with broad knife strokes. The completed alkyd painting faithfully records every nuance of the artist's personal "handwriting."